OCEAN ANATOMY

ANATOMY

THE CURIOUS PARTS & PIECES OF THE WORLD UNDER THE SEA

JULIA ROTHMAN

BEST-SELLING AUTHOR OF THE ANATOMY SERIES

WITH HELP FROM JOHN NIEKRASZ

The mission of Storey Publishing is to serve our customers by
publishing practical information that encourages
personal independence in harmony with the environment.

Storey books are available at special discounts when purchased in bulk for premiums
and sales promotions as well as for fund-raising or educational use. Special editions or
book excerpts can also be created to specification. For details, please send an email
to special.markets@hbgusa.com.

Storey Publishing
210 MASS MoCA Way
North Adams, MA 01247
storey.com

Storey Publishing, LLC is an imprint of Workman Publishing Co., Inc., a subsidiary of Hachette Book Group,
Inc., 1290 Avenue of the Americas, New York, NY 10104

Distributed in Europe by Hachette Livre, 58 rue Jean Bleuzen, 92 178 Vanves Cedex, France. Distributed
in the United Kingdom by Hachette Book Group, UK, Carmelite House, 50 Victoria Embankment, London
EC4Y 0DZ

ISBNs: 978-1-63586-160-0 (Paperback); 978-1-63586-161-7 (eBook), 978-1-63586-348-2 (fixed
layout eBook); 978-1-63586-349-9 (Kindle print replica/KF8)

Printed in China by R. R. Donnelley on paper from responsible sources
10 9 8 7 6

Library of Congress Cataloging-in-Publication Data on file

For my City Island friends,
especially Civi, Laur, and Niner
(who once adopted a manatee)

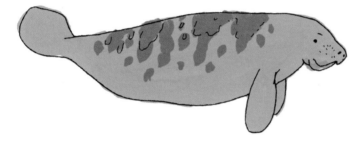

CONTENTS

INTRODUCTION ... 6

CHAPTER 1

A Drop in the Ocean 11

The Earth Is Ocean-Unique • World Ocean • Why Is the Ocean Salty? • Speed of Sound • The Breakup of Pangea • Trade Winds • Features of the Ocean Floor • Tides • Ocean Currents • Waves • Rogue Waves • Ocean Depth Zones

CHAPTER 2

Plenty of Fish in the Sea 29

Ocean Food Chain • Sun-lit Producers • Bioluminescence • Anatomy of a Fish • Fish Facts • Schooling Fish • Predatory Fish • Anatomy of a Shark • Sharks by Size • Sharks • Rays • Anatomy of a Jellyfish • Jellyfish Facts • Lifecycle of a Jellyfish • Deep Sea Creatures

CHAPTER 3

A Whale of a Time 57

Anatomy of a Whale • Whales Big and Small • Bubble-Net Feeding • Anatomy of a Dolphin • Dolphin vs. Porpoise • Echolocation • Dolphin Species • Orcas • Threatened Whales • Manatees

CHAPTER 4

Life's a Beach79

Sand • Anatomy of a Beach • Tide Pools • Tidal Zone Ecosystem • Shell Shapes • Anatomy of a Shell • So Many Shells • Seaweed • Kelp Forest • Barnacles • Razor Clams • Shorebirds • Ocean Birds • Inshore Fish • Anatomy of a Crab • Tiny + Giant Crabs • Hermit Crabs • Anatomy of a Snail • Anatomy of a Scallop

CHAPTER 5

Dive In!... 113

The Ocean Floor • Sea Cucumbers • Tripod Fish • Hunting Together: Groupers and Moray Eels • Basket Starfish • Anatomy of an Octopus • Inside an Octopus • Squid vs. Cuttlefish • Squid • Cuttlefish • Nautilus • Pearls • Anatomy of a Lobster • Lobsters • Shrimp & Prawns • Anatomy of a Shrimp • Starfish • Anemones • Sea Turtle Identification • Sea Turtles • Great Migrations

CHAPTER 6

Reef Madness.. 141

Coral Reefs • Reef Zones • Coral Polyps • Coral • Fish in Coral Reefs • The Great Barrier Reef • Anatomy of a Seahorse • Sponges • Sea Grass • Nudibranch

CHAPTER 7

Chill Out..159

Sea Ice • Life Under the Ice • Glaciers • Icebergs • Sea Lion vs. Seal • Narwhals • Penguins • Penguin Size Comparison • Polar Bears

CHAPTER 8

From Sea to Shining Sea........................181

Low-Impact Fishing • High-Impact Fishing • Lighthouses • Moving Cape Hatteras Lighthouse • Studying the Ocean • Studying the Sea with Alvin • Scuba • Commerce on the Seas • Cargo Ships • Great Pacific Garbage Patch • Climate Change in Numbers • Some Good News

RECOMMENDED READING.........204

SELECTED RESOURCES AND BIBLIOGRAPHY............................ 206

THANK YOU!....................................207

INTRODUCTION

*A*t the end of the street where I grew up on City Island, there was a beach. As a kid, I would walk the shore when the tide was out, looking for hermit crabs, starfish, and whatever else washed up. When the tide was high, we would swim in the bay. For bigger surf, we headed to Jones Beach on Long Island. With each huge wave, my sister and I had three choices: jump over, duck under it, or try to ride it to shore. I can still feel the burning sensation of saltwater going up my nose.

My family has always treasured being near the water. My parents still live in that house. Every summer evening they go down to the beach to join the "sunset club," where they chat with neighbors while the waves lap and the sun goes down.

Working on my books — *Farm Anatomy*, *Nature Anatomy*, and *Food Anatomy* — has led me to explore the world in a deeper way. But each book takes over a year to create, and I couldn't imagine doing another one. But then readers changed my mind. I received emails from people from around the world telling me how much they loved the books.

On Instagram, posts showed kids learning from them, carrying them on nature walks, and copying drawings from them.

I also received handwritten letters from kids. Some drew me pictures, like vegetables growing or flowers in a rainbow of colors. They told me which book they liked best or what they loved about nature or

about their favorite food or animal. I cherish these letters. Twelve-year-old Lydia from Maine wrote, "Since I was younger, I dreamed of becoming a marine biologist. I think growing up on the coast influenced this. I love your books and I would really enjoy one called *Ocean Anatomy*. I was wondering if you ever decided to make another book if you would consider the topic."

I thought of my memories of my childhood beach. I thought about the first time I went snorkeling and saw brightly colored fish. I also thought about climate change and how it was affecting our beautiful oceans and the images I saw of starving polar bears. But most of all, I thought of Lydia becoming a marine biologist, and all the children who had written to me, and I decided to do another book.

So here I am.

I enlisted the help of the wonderful John Niekrasz who worked with me on *Nature Anatomy* to collaborate with me again. He has done extensive research on all the plants and animals in the ocean and on the shores. We tried to include as much as we could. Along the way, I learned about so many jaw-dropping animals I had

drawing by Chloe

never heard of — nudibranchs, giant spider crabs, leafy sea dragons. And I spent nights worrying what would happen to our beautiful oceans as the Great Pacific Garbage Patch grows and turtles confuse plastic bags for jellyfish and eat them.

I hope this book opens your eyes to all the incredible sea life we don't even realize is there. I hope this book reminds you how much we need to conserve all these fascinating plants and creatures. I hope more children are inspired to get involved and learn how to protect and save our marvelous oceans.

Julia Rothman

Dear Julia Rothman,

I have written to express my love o
book, *Nature Anatomy: The Curious Parts and*
the Natural World. First of all, I love you
and how detailed and beautiful they loo
perfectly capture how wondrous nature
They are colorful and compliment each
Your book has inspired me. When I f
it, it was in my school library, and
else was holding it. They said, "Do
it?", and I accepted. I immediately l
tra.........
in
alu
inc
exp

P.
S

Dear, Julia Rothman

I love your book Food

I love how you explain

how chocolate ar...

how to eat with

and how to use

my favorite cha

Street food and

I also love the p

8

—from Cole

drawing by Chloe

atomy!

out
d

—from Molly

from Lydia

would really enjoy a book called
"Ocean Anatomy". I was wondering
if you ever decided to make
another book if you would
consider this topic.

CHAPTER 1

A Drop in the Ocean

THE EARTH IS
OCEAN – UNIQUE

Oceans are Earth's defining feature. This is the only known planet in the universe with stable bodies of liquid water. Water is essential for life and all life began in the ocean about three and a half billion years ago.

BUT WHERE IS
WATER FROM?

Water covers 71 percent of the earth's surface but scientists still aren't certain where it came from! Water may have come to our planet billions of years ago on asteroids or comets, both of which sometimes contain ice. There is also water inside rock within the earth's mantle that likely contributed to the formation of our oceans.

AND WHY DOES THE OCEAN APPEAR BLUE?

The surface of the ocean reflects the color of the sky. On cloudy days, the ocean appears gray. When sunlight shines on the ocean, water molecules absorb light in the red part of the spectrum first. Red, orange, and yellow wavelength colors disappear. They act as a filter, leaving behind colors in the blue part of the spectrum.

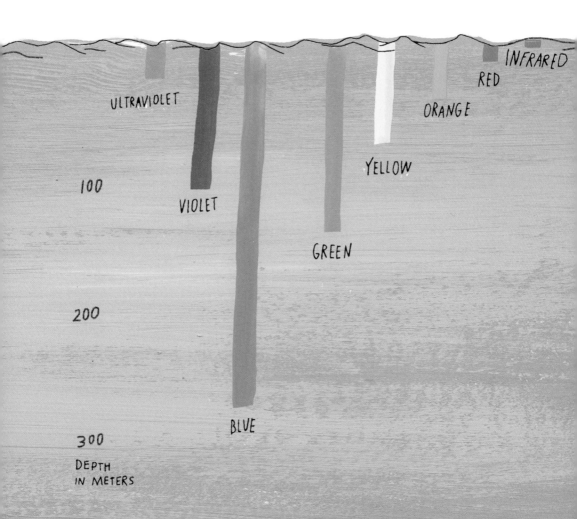

INFRARED

RED

ORANGE

ULTRAVIOLET

YELLOW

100

VIOLET

GREEN

200

BLUE

300

DEPTH
IN METERS

WORLD OCEAN

All five of the earth's oceans are connected and exchange water like a single, enormous World Ocean.

ATLANTIC OCEAN

- Covers 20 percent of the earth's surface
- Slowly growing as tectonic plates spread outward from the Mid-Atlantic Ridge
- Average depth 11,000 feet
- Encompasses the Mediterranean Sea

PACIFIC OCEAN

- Covers one third of the earth's surface
- Slowly shrinking as tectonic plates shift
- Average depth 12,000 feet
- Home to the deepest point on Earth: Challenger Deep (36,000 feet/7 miles)

SOUTHERN OCEAN

ARCTIC OCEAN
- Covers 2.6 percent of the earth's surface
- Smallest and shallowest ocean
- Average depth 4,000 feet

PACIFIC OCEAN

INDIAN OCEAN
- Covers 14 percent of the earth's surface
- Average depth nearly 13,000 feet
- Encompasses the Persian Gulf and Red Sea

- Covers 4 percent of the earth's surface
- Known as the Antarctic Ocean until 2000
- Average depth about 14,000 feet
- Has seasonal ice cover

WHY IS THE OCEAN SALTY?

The saltiness, or salinity, of the ocean comes from the land. Over eons, rainfall erodes rocky land and dissolves minerals. Rivers carry these minerals to the oceans where they accumulate. Sodium and chloride are the most common "salty" ions in our oceans.

The salinity of the world's oceans averages thirty-five parts salt per thousand, or 3.5 percent salt.

Ninety-seven percent of all water on Earth is saltwater. For thousands of years, humans have harvested salt by evaporating ocean water.

SALT FLATS

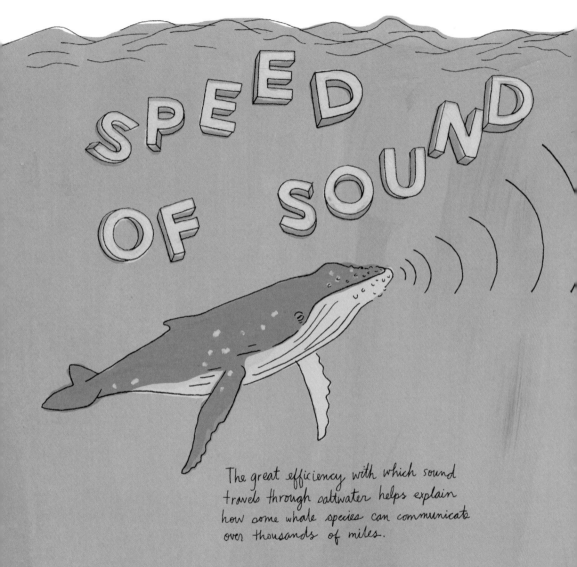

SPEED OF SOUND

The great efficiency with which sound travels through saltwater helps explain how some whale species can communicate over thousands of miles.

Sound moves through water about four times faster than it does through air. Water is more dense than air and sound passes through the tightly packed molecules quickly. Ocean water near 70°F (21°C) transmits sound at about a mile per second, much faster than the fastest jet plane can fly.

THE BREAKUP OF PANGEA

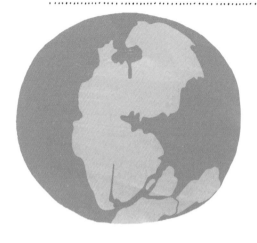

290 MILLION YEARS AGO

Most of the continents of the earth were crowded into a supercontinent called Pangea. A superglobal ocean called Panthalassa surrounded Pangea and to the east lay the enormous Paleo-Tethys sea.

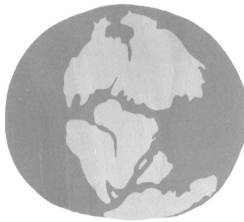

200 MILLION YEARS AGO

With the gradual movement of the earth's tectonic plates, Pangea began to break apart.

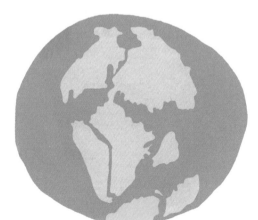

180 MILLION YEARS AGO

The first of our modern oceans, the central Atlantic Ocean and the southwestern Indian Ocean, appeared.

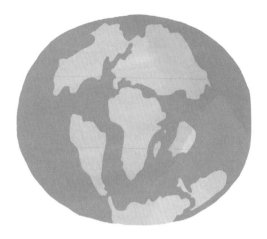

140 MILLION YEARS AGO

The southern Atlantic Ocean emerged as South America pulled away from Africa. The central Indian Ocean appeared as India separated from Antarctica.

80 MILLION YEARS AGO

North America broke off from Europe, forming the northern Atlantic. Eventually, the earth's continents and oceans emerged in their current forms.

Trade Winds

Near the equator, winds from the east blow steadily all the way around the earth. Early sailors from Europe and Africa used these winds and the resulting currents to reach America, allowing them to establish colonies and trading routes. They named these reliable gusts the Trade Winds.

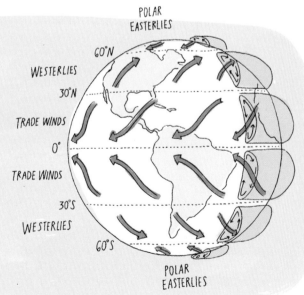

POLAR EASTERLIES

60°N — WESTERLIES

30°N

TRADE WINDS

0°

TRADE WINDS

30°S — WESTERLIES

60°S

POLAR EASTERLIES

Features of the Ocean Floor

Bathymetry is the study of the underwater depth and features of the ocean floor, as well as rivers, streams, and lakes.

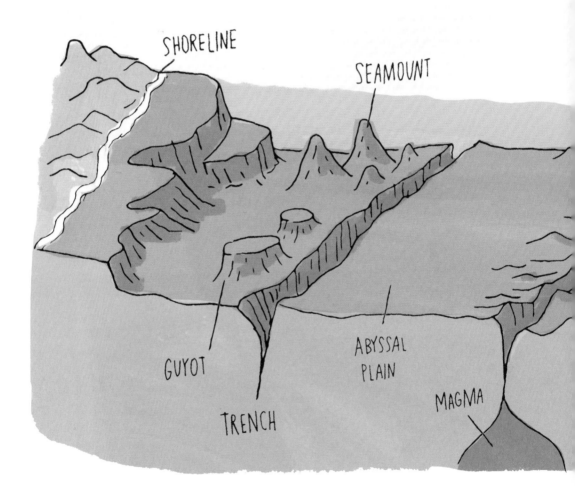

SHORELINE

SEAMOUNT

GUYOT

TRENCH

ABYSSAL PLAIN

MAGMA

Seamounts are volcanic mountains that arise from the ocean floor without breaching the surface. They can stand alone or run in long chains. An eroded seamount is called a guyot or tablemount.

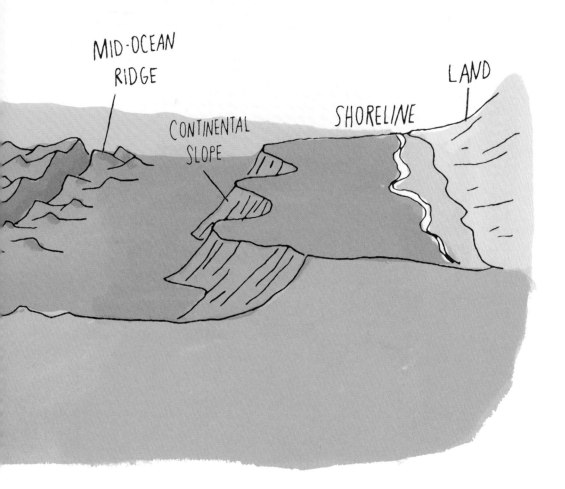

MID-OCEAN
RIDGE

CONTINENTAL
SLOPE

SHORELINE

LAND

Tides

The tides of the ocean result from the gravity of the moon and the sun pulling on the enormous mass of water. Ocean water bulges outward in the direction of the moon. As the earth rotates beneath the drawn mass of ocean water, twice-per-day high and low tides occur on shorelines.

The difference between high and low tide varies according to the position of the sun and moon. The greatest difference, called a spring tide, occurs when those bodies align just after a new or full moon. The smallest difference, a neap tide, comes seven days after a spring tide. That's when the sun and moon are at right angles to each other, which diffuses the gravitational pull.

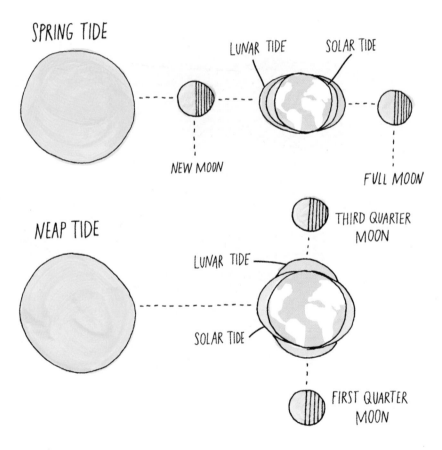

SPRING TIDE

LUNAR TIDE SOLAR TIDE

NEW MOON

FULL MOON

NEAP TIDE

THIRD QUARTER MOON

LUNAR TIDE

SOLAR TIDE

FIRST QUARTER MOON

In some places, the tidal difference is as little as 3 feet. In Canada's Bay of Fundy, the difference between high and low tide can be as great as 50 feet!

Without tidal action, life as we know it might not exist. The churning of tides ensures the constant circulation of ocean nutrients.

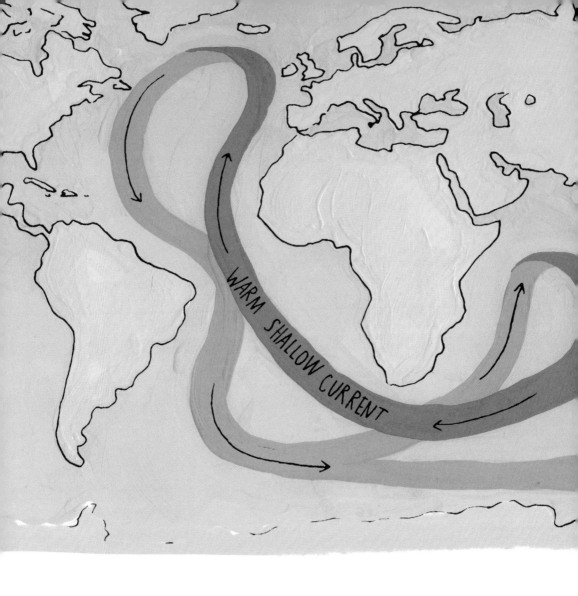

WARM SHALLOW CURRENT

OCEAN CURRENTS

TIDES are one of three factors that cause ocean currents. The current caused by an incoming tide is called a flood current. As the tide recedes, it causes an ebb current to flow. Tidal currents are only strong near shore.

WINDS are responsible for some surface ocean currents. Depending on season and location, wind can drive strong ocean currents three hundred feet deep.

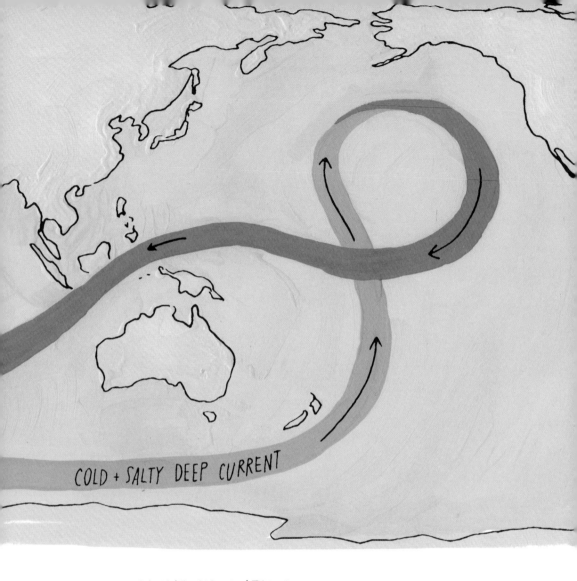

COLD + SALTY DEEP CURRENT

THERMOHALINE CIRCULATION, water movement based on differences in temperature and saltiness, is the primary driver of deep-ocean currents. When ice forms in ocean water near the poles, the surrounding cold water becomes saltier and more dense. The cold, dense, salty water sinks to the bottom and warmer surface water takes its place. This density-driven circulation forms currents deep in the ocean.

CURRENTS can significantly alter the climate on land. Even though Peru is only 12 degrees south of the Equator, the chilly Humboldt Current keeps it cool. In contrast, the Gulf Stream keeps Norway much warmer than its northern latitude would suggest.

WAVES

As swells travel away from distant storms, waves tend to travel together in groups called sets. It's often said there are 7 waves to a set, but most commonly the number is somewhere from 12 to 16, with the largest waves in the middle of the set.

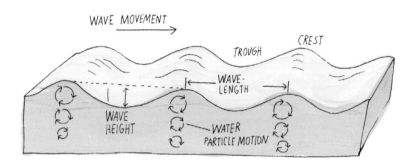

Rogue Waves

Very rarely, when wind and current conditions are just right, ocean waves can unexpectedly merge to form a single wave that is twice as tall (or taller!) than the surrounding waves. These large, freak waves, often called rogue waves, can be destructive to ships and shorelines.

OCEAN DEPTH ZONES

1. SUNLIGHT - EPIPELAGIC ZONE
Sunlight brings abundant life and a range of temperatures.

2. TWILIGHT - MESOPELAGIC ZONE
Sunlight is very faint. Unusual-looking fish and other sea creatures live here, including many with bioluminescence.

3. MIDNIGHT - BATHYPELAGIC ZONE
Despite the crushing water pressure, some whales are known to dive to and feed at these depths.

4. ABYSS - ABYSSALPELAGIC ZONE
The temperature is very cold, but squid and starfish can survive here.

5. TRENCHES - HADALPELAGIC ZONE
With eight tons of water pressure per square inch, life is rare, but still exists in the form of tube worms and other invertebrates.

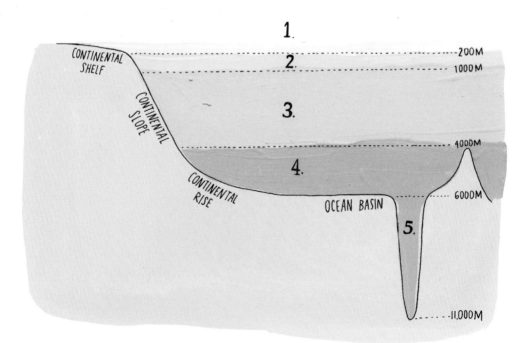

CHAPTER 2

Plenty of Fish in the Sea

Ocean Food Chain

Primary Producers

PHYTOPLANKTON use sunlight to make their own food through photosynthesis. These one-celled microalgae remain suspended in ocean water and transfer the sun's energy up the aquatic food web to larger creatures that consume them.

Primary consumers

ZOOPLANKTON are tiny marine animals that feed on phytoplankton. There are thousands of different species of zooplankton and most live near the surface.

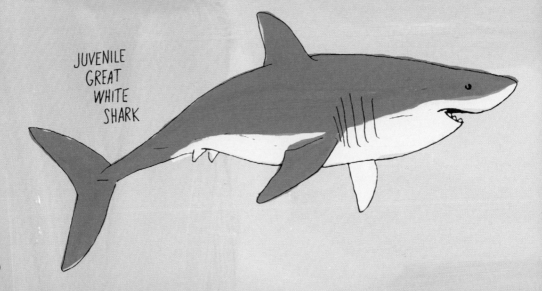

JUVENILE
GREAT
WHITE
SHARK

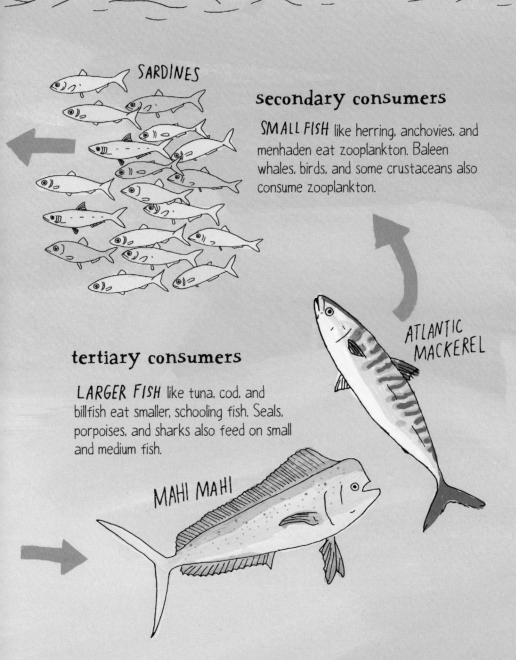

SARDINES

secondary consumers

SMALL FISH like herring, anchovies, and menhaden eat zooplankton. Baleen whales, birds, and some crustaceans also consume zooplankton.

tertiary consumers

LARGER FISH like tuna, cod, and billfish eat smaller, schooling fish. Seals, porpoises, and sharks also feed on small and medium fish.

ATLANTIC MACKEREL

MAHI MAHI

SuN-LIT PRODuCERS

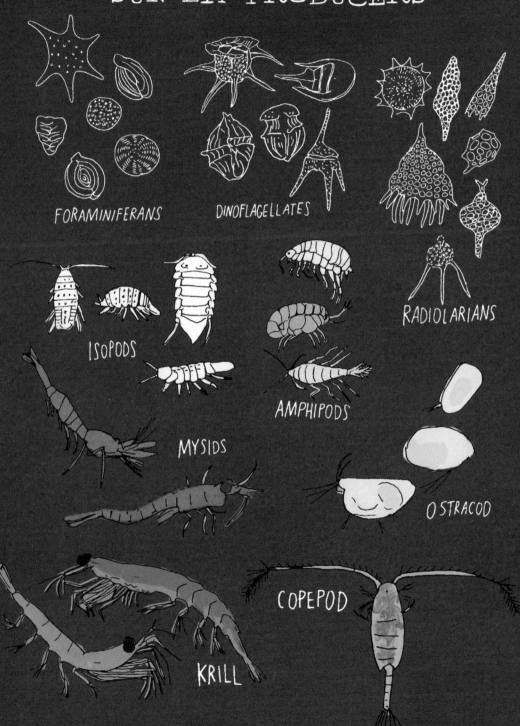

FORAMINIFERANS

DINOFLAGELLATES

RADIOLARIANS

ISOPODS

AMPHIPODS

MYSIDS

OSTRACOD

COPEPOD

KRILL

Bioluminescence

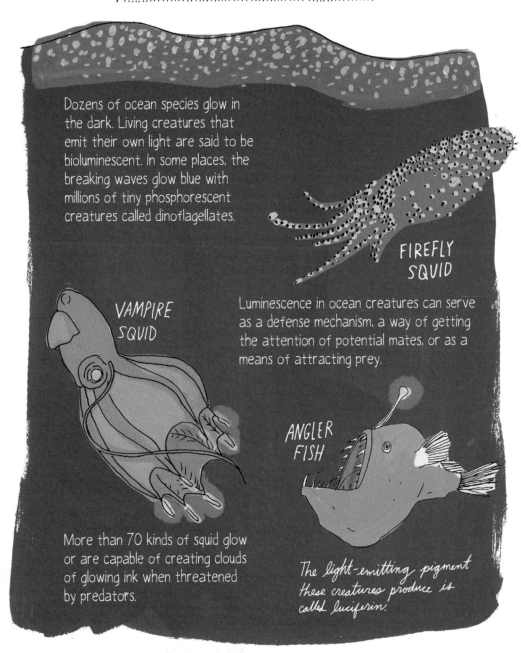

Dozens of ocean species glow in the dark. Living creatures that emit their own light are said to be bioluminescent. In some places, the breaking waves glow blue with millions of tiny phosphorescent creatures called dinoflagellates.

FIREFLY SQUID

VAMPIRE SQUID

Luminescence in ocean creatures can serve as a defense mechanism, a way of getting the attention of potential mates, or as a means of attracting prey.

ANGLER FISH

More than 70 kinds of squid glow or are capable of creating clouds of glowing ink when threatened by predators.

The light-emitting pigment these creatures produce is called luciferin.

ANATOMY OF A FISH

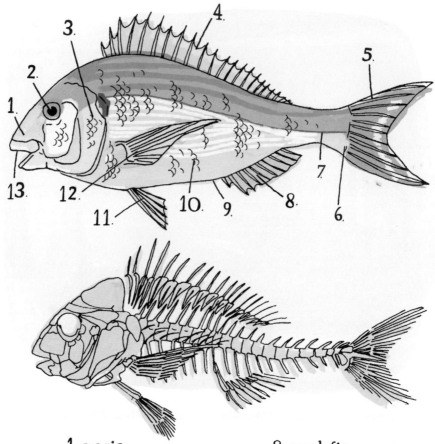

1. naris
2. eye
3. operculum gill cover
4. dorsal fin
5. caudal fin
6. peduncle
7. lateral line
8. anal fin
9. vent
10. scales
11. pelvic fin
12. pectoral fin
13. mouth

FISH FACTS

Fish are animals that live in water, have fins, and use gills to breathe. Most fish have scales, skeletons of bone or cartilage, and lay eggs.

FISH EGG
HATCHING FISH

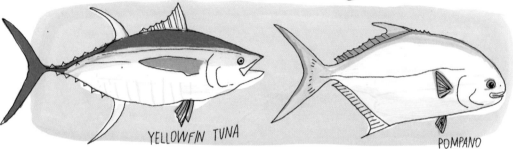

YELLOWFIN TUNA

POMPANO

Fish make up more than half of all vertebrate animals. There are at least 30,000 different species of fish, making them the most diverse group of vertebrates. They are found in all aquatic environments, but the ocean is home to the greatest number of fish.

Most fish are cold-blooded, allowing their body temperatures to change with their surroundings. A handful of larger fish, like tuna, opah, and some sharks, have warmer, more stable blood temperatures.

Fish draw oxygen-containing water into their mouths and pump it over their gills. Fish gills contain networks of blood vessels that efficiently exchange oxygen and carbon dioxide. The oxygen passes through the walls of the capillaries directly into the blood while the carbon dioxide is carried away by the water.

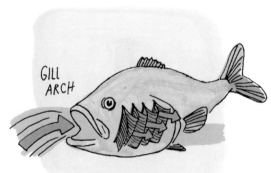

GILL ARCH

Fish have a highly developed set of sense organs on both sides of their bodies. These lateral lines detect movement and pressure variants in water, helping fish navigate and home in on prey.

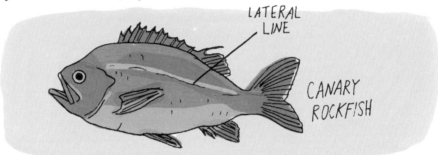

LATERAL LINE

CANARY ROCKFISH

Fish may be carnivores, herbivores, or omnivores, and some species eat different foods at different points in their development. Plankton, coral, algae, crustaceans, worms, cephalopods, molluscs, and other fish are common prey.

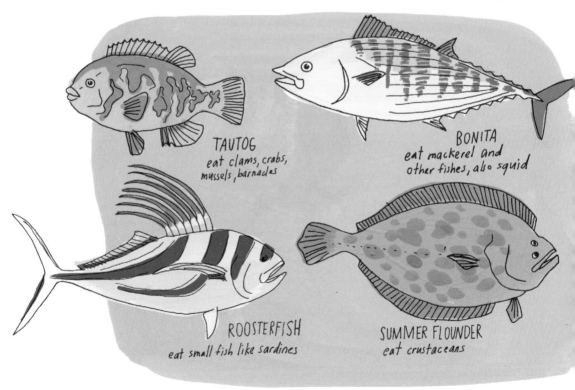

TAUTOG
eat clams, crabs, mussels, barnacles

BONITA
eat mackerel and other fishes, also squid

ROOSTERFISH
eat small fish like sardines

SUMMER FLOUNDER
eat crustaceans

Schooling Fish

Many species of fish live and travel in groups called schools. Schooling fish are highly aware of their position within the group and they synchronize their movements to respond to predators, prey, and currents. Schooling helps fish avoid predators, allows them to swim more efficiently over distance, and can even help them hunt.

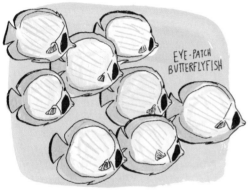

EYE-PATCH BUTTERFLYFISH

Fish do not learn to swim together in schools; the ability is built into their genes. The lateral line organs help fish school in tight formation.

A shoal is a loose school in which the fish do not synchronize their movements.

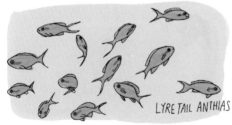

LYRETAIL ANTHIAS

Herring have been known to travel in mile-long schools comprising millions of individuals.

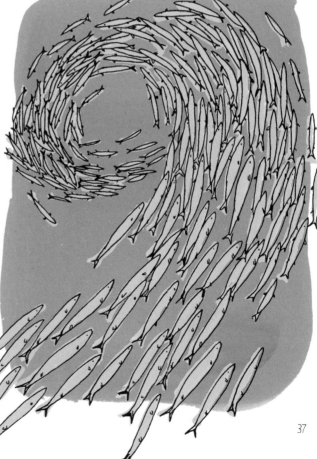

PREDATORY FISH

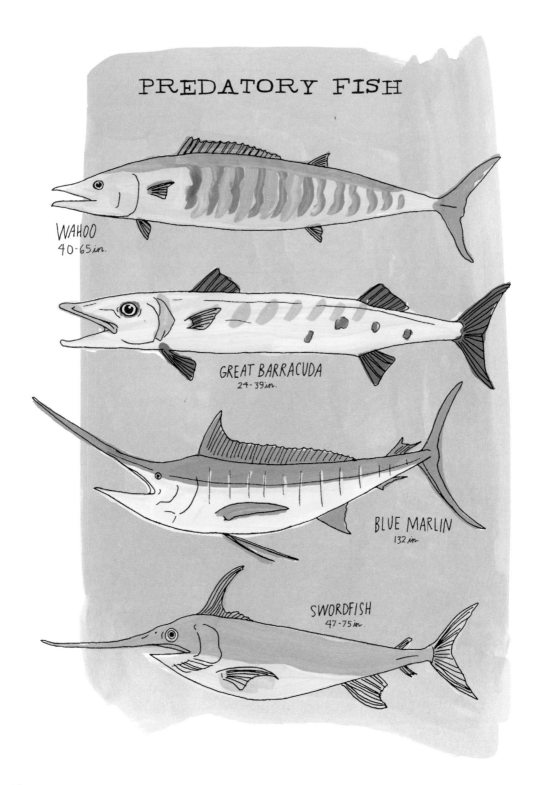

WAHOO
40-65 in.

GREAT BARRACUDA
24-39 in.

BLUE MARLIN
132 in.

SWORDFISH
47-75 in.

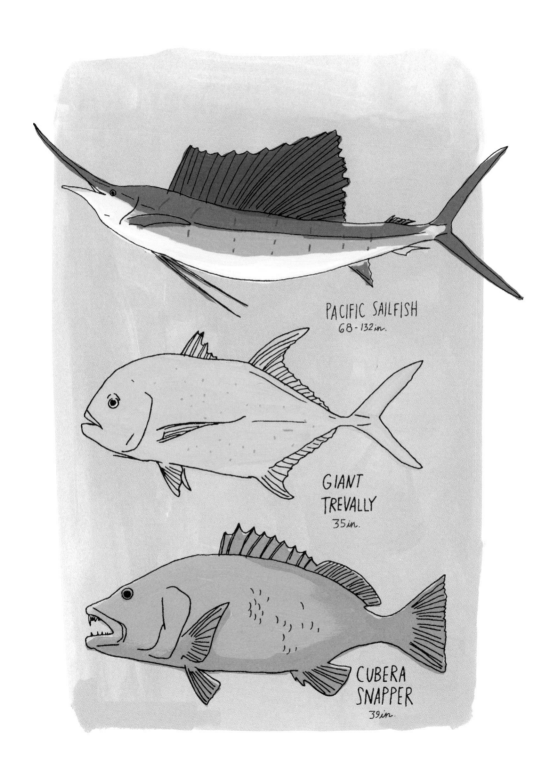

PACIFIC SAILFISH
68 - 132 in.

GIANT
TREVALLY
35 in.

CUBERA
SNAPPER
39 in.

ANATOMY OF A SHARK

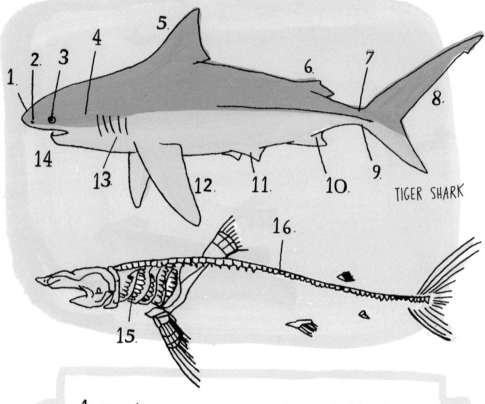

TIGER SHARK

1. snout
2. nostril
3. eye
4. spiracle
5. first dorsal fin
6. second dorsal fin
7. precaudal pit
8. caudal fin

9. caudal keel
10. anal fin
11. pelvic fin
12. pectoral fin
13. gill openings
14. mouth
15. gill arch
16. backbone or spine

A single fin slicing through the surface of the water invokes terror for those who suffer from galeophobia, a fear of sharks.

Sharks have a fearsome reputation as calculating, vengeful hunters with a taste for humans, but lightning and lawnmowers are far more dangerous. Fewer than a dozen of the more than 500 shark species pose any threat to us. In a typical year, there are fewer than 90 shark attacks in the entire world, few of which are fatal. Meanwhile, more than 100 million sharks are killed each year by humans.

The oldest shark relatives first appeared nearly half a billion years ago, well before any vertebrate land animals. Sharks as we know them have been around for about 100 million years. As a frame of reference, modern humans are only about 200,000 years old.

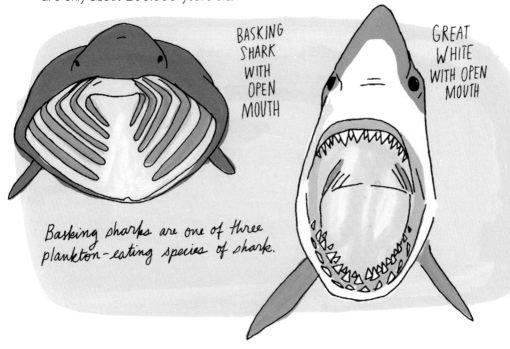

BASKING SHARK WITH OPEN MOUTH

GREAT WHITE WITH OPEN MOUTH

Basking sharks are one of three plankton-eating species of shark.

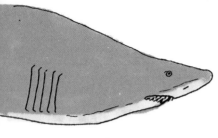

GILLS

NICTITATING MEMBRANE

Sharks have nictitating membranes, extra sets of translucent eyelids that protect their eyes when they go in for a bite.

Sharks have five to seven gill slits on the sides of their heads. They have skeletons made of cartilage that are lighter and more flexible than bone. Sharks do not have air bladders like fish, but oil-filled glands to help them stay buoyant. Because they lack a ribcage, they can collapse under their own weight when brought onto dry land.

If you're brave enough to peer into a shark's mouth, you'll see several rows of teeth. Shark's teeth replace themselves automatically, slowly moving outward as if on a conveyor belt. Only the outer two rows of teeth are functional at any given time.

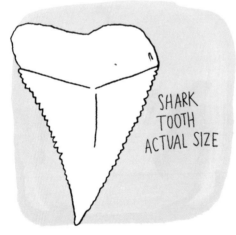

SHARK TOOTH ACTUAL SIZE

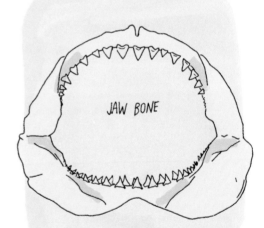

JAW BONE

Sharks may grow and lose 20,000 or more teeth in a lifetime, which is why fossilized shark teeth are some of the more commonly found fossils.

Shark skin feels like coarse sandpaper when brushed backwards, but is extremely smooth and hydrodynamically efficient as it moves forward through water. The skin is made up of tiny tooth-like placoid scales, or dermal denticles. The scales are protectively hard like enamel and very streamlined; small vortices form around each scale limiting drag and turbulence.

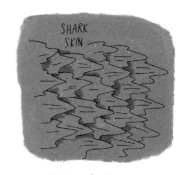

SHARK SKIN

Sharks have a secret hunting super power – a network of electroreceptive pores on their heads that helps them sense the electrical fields of their prey. These pores are called the ampullae of Lorenzini. They can even detect the beating heart of a fish that isn't moving.

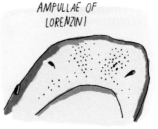

AMPULLAE OF LORENZINI

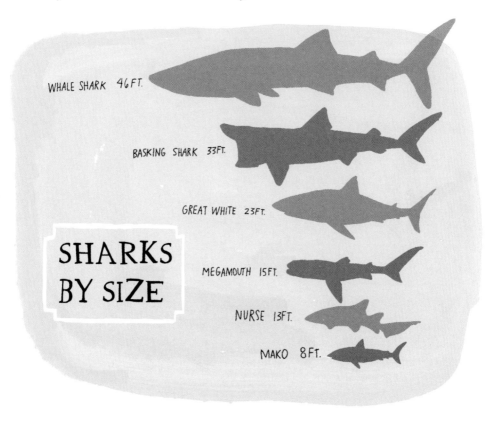

WHALE SHARK 46 FT.

BASKING SHARK 33 FT.

GREAT WHITE 23 FT.

SHARKS BY SIZE

MEGAMOUTH 15 FT.

NURSE 13 FT.

MAKO 8 FT.

SHARKS

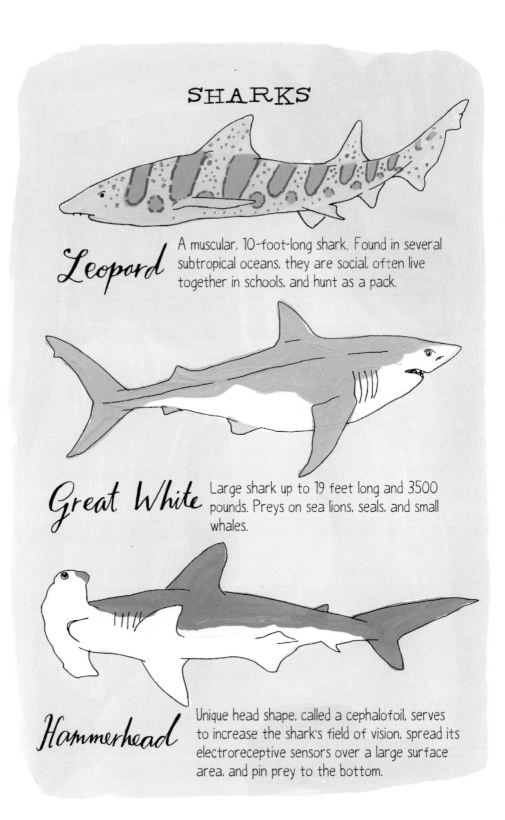

Leopard A muscular, 10-foot-long shark. Found in several subtropical oceans, they are social, often live together in schools, and hunt as a pack.

Great White Large shark up to 19 feet long and 3500 pounds. Preys on sea lions, seals, and small whales.

Hammerhead Unique head shape, called a cephalofoil, serves to increase the shark's field of vision, spread its electroreceptive sensors over a large surface area, and pin prey to the bottom.

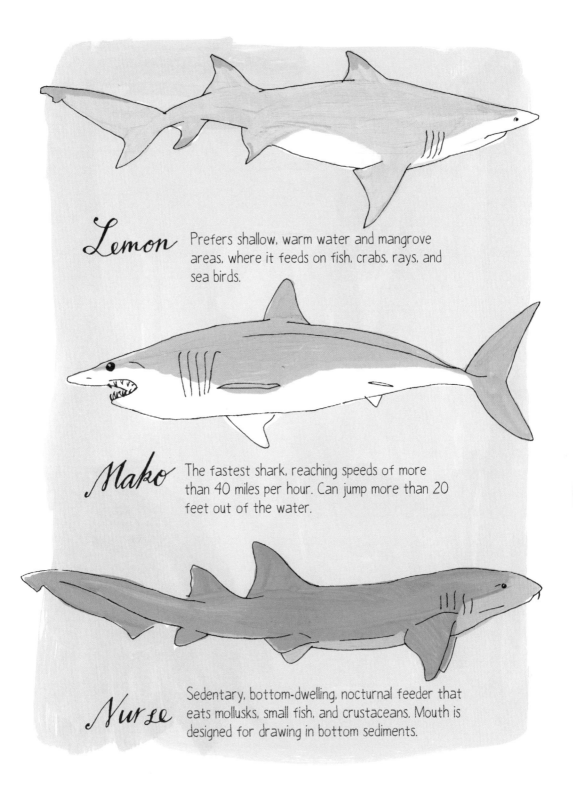

Lemon — Prefers shallow, warm water and mangrove areas, where it feeds on fish, crabs, rays, and sea birds.

Mako — The fastest shark, reaching speeds of more than 40 miles per hour. Can jump more than 20 feet out of the water.

Nurse — Sedentary, bottom-dwelling, nocturnal feeder that eats mollusks, small fish, and crustaceans. Mouth is designed for drawing in bottom sediments.

RAYS

These flat-bodied relatives of sharks also have skeletons made of cartilage. Rays have gills on their undersides and their pectoral fins function as large, propulsive wings.

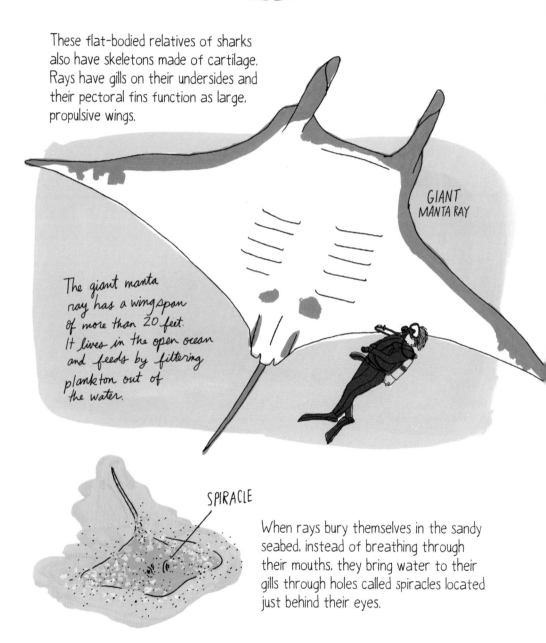

GIANT MANTA RAY

The giant manta ray has a wingspan of more than 20 feet. It lives in the open ocean and feeds by filtering plankton out of the water.

SPIRACLE

When rays bury themselves in the sandy seabed, instead of breathing through their mouths, they bring water to their gills through holes called spiracles located just behind their eyes.

There are more than 600
species of marine rays. The
majority live on the ocean
floor, feeding on crustaceans,
gastropods, and molluscs.

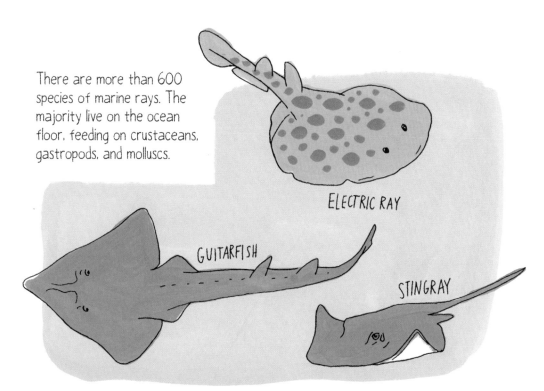

ELECTRIC RAY

GUITARFISH

STINGRAY

Stingrays are not aggressive, but they have a poisonous barb in their tails
to defend themselves if disturbed. When walking through water where
stingrays are known to live, it is safest to shuffle along the bottom instead
of taking big steps.

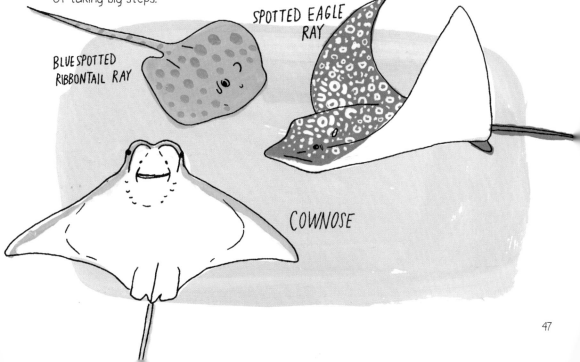

SPOTTED EAGLE
RAY

BLUE SPOTTED
RIBBONTAIL RAY

COWNOSE

ANATOMY OF A JELLYFISH

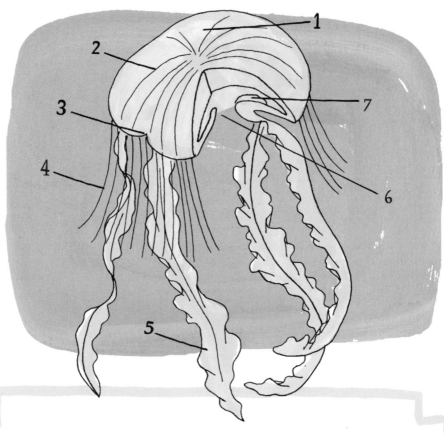

1. **bell** - umbrella-shaped body that contracts and expels water from the cavity underneath to propel the jellyfish

2. **canal** -a series of tubes that run along the bell to distribute nutrients throughout the body in what's called extracellular digestion

3. **eyespot** - light-sensitive spots on the rim of the bell

4. **tentacle** - used for touching

5. **oral arm** - injects the prey with venom

6. **mouth** - prey goes through here to the gastric cavity

7. **gonad** - reproductive organs that produce sperm and/or egg cells

JELLYFISH FACTS

Jellyfish are not fish at all. What we call jellyfish are actually the medusa, or adult, phase of a group of animals called cnidarians [nahy-dair-ee-uhns] that are more closely related to corals and anemones than fish.

Jellyfish evolution predates that of true fish by at least 100 million years.

There are about 1,500 different species of jellyfish. Jellyfish are expanding in numbers even as ocean waters warm and become more acidic and polluted.

Jellyfish tentacles contain stinging nematocyst cells that shoot microscopic, poisonous barbs when they come into contact with prey such as small fish, krill, crustaceans, and even other jellyfish.

Not all jellyfish can sting humans, but a few, like the box jelly, are lethally poisonous.

A group of jellyfish is called a swarm or a bloom. Large blooms may contain millions of jellyfish and cover 10 square miles.

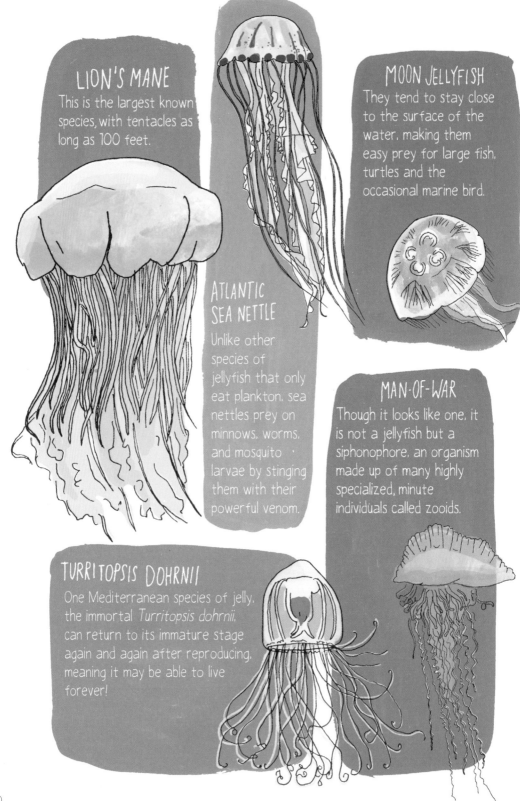

LION'S MANE
This is the largest known species, with tentacles as long as 100 feet.

MOON JELLYFISH
They tend to stay close to the surface of the water, making them easy prey for large fish, turtles and the occasional marine bird.

ATLANTIC SEA NETTLE
Unlike other species of jellyfish that only eat plankton, sea nettles prey on minnows, worms, and mosquito larvae by stinging them with their powerful venom.

MAN-OF-WAR
Though it looks like one, it is not a jellyfish but a siphonophore, an organism made up of many highly specialized, minute individuals called zooids.

TURRITOPSIS DOHRNII
One Mediterranean species of jelly, the immortal *Turritopsis dohrnii*, can return to its immature stage again and again after reproducing, meaning it may be able to live forever!

Lifecycle of a Jellyfish

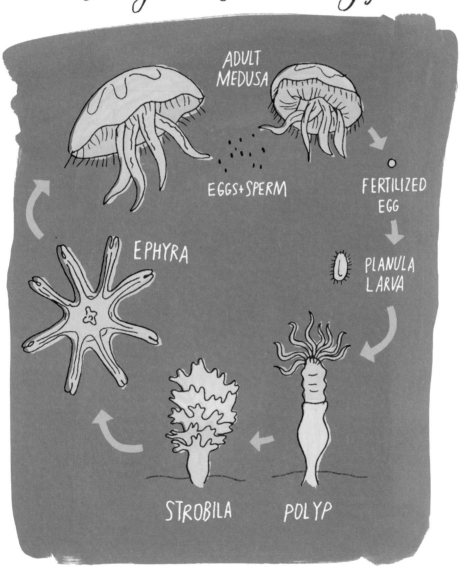

ADULT MEDUSA

EGGS+SPERM

FERTILIZED EGG

PLANULA LARVA

EPHYRA

STROBILA

POLYP

DEEP SEA CREATURES

The deep sea is a cold, dark place. At 200 yards below the surface, only about one percent of the sun's light is visible and the water temperature averages 32-37° F (0-3° C). The pressure of water on animals living miles below the surface is incredible. Every 30 feet of depth adds one atmosphere of pressure. Three miles below the surface, animals have to contend with the weight of about 500 atmospheres pressing down on them. Yet life flourishes even in the deepest, darkest parts of the ocean.

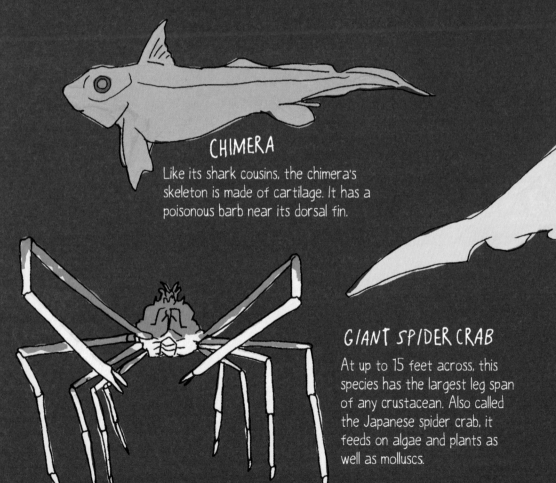

CHIMERA

Like its shark cousins, the chimera's skeleton is made of cartilage. It has a poisonous barb near its dorsal fin.

GIANT SPIDER CRAB

At up to 15 feet across, this species has the largest leg span of any crustacean. Also called the Japanese spider crab, it feeds on algae and plants as well as molluscs.

PELICAN EEL

Also called the gulper eel because of its prominent hinged mouth, it attracts prey with pink and red bioluminescent cells at the end of its tail.

GOBLIN SHARK

This pinkish-skinned shark can extend its jaws out many inches when feeding. The grenadier fish is one of its common prey.

DUMBO OCTOPUS

Growing up to 5 feet long, it has been observed at depths of greater than 20,000 feet, deeper than any other octopus species. It propels itself with its ear-like flaps, steering with its arms.

HATCHETFISH

Bioluminescence in its body serves as camouflage. Light-sensitive eyes point upward to see prey against the dimly lit surface.

PACIFIC VIPERFISH

Though scary looking, this fish only reaches about one foot in length. Bioluminescent photophores on its long dorsal spine attract prey.

GIANT SQUID

Growing to 40 feet long and
weighing as much as 2,000 pounds,
its eyes may be as large as 12 inches
across. They live only about 5
years, during which they may mate
just once. These squid live in every
ocean, but since they are rare and
live at such great depth, they
weren't filmed in the wild until 2012.

*The only invertebrate larger
than the giant squid is its
cousin, the colossal squid!*

GIANT TUBE WORMS

Giant tube worms thrive rear deep
ocean thermal vents, using bacteria
to help them digest hydrogen sulfide.

COMMON FANGTOOTH

Although only about seven inches long, it has long, sharp teeth for catching other fish, crustaceans, and cephalopods.

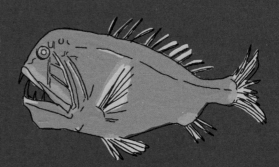

BLACK SWALLOWER

With an incredibly expandable stomach, this 10-inch predator can consume fish more than twice its length and many times its weight.

PACIFIC GRENADIER

Also called rattail because of its dramatically tapering body, grenadiers are the most common family of fish found at extreme depths.

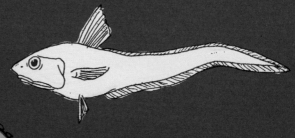

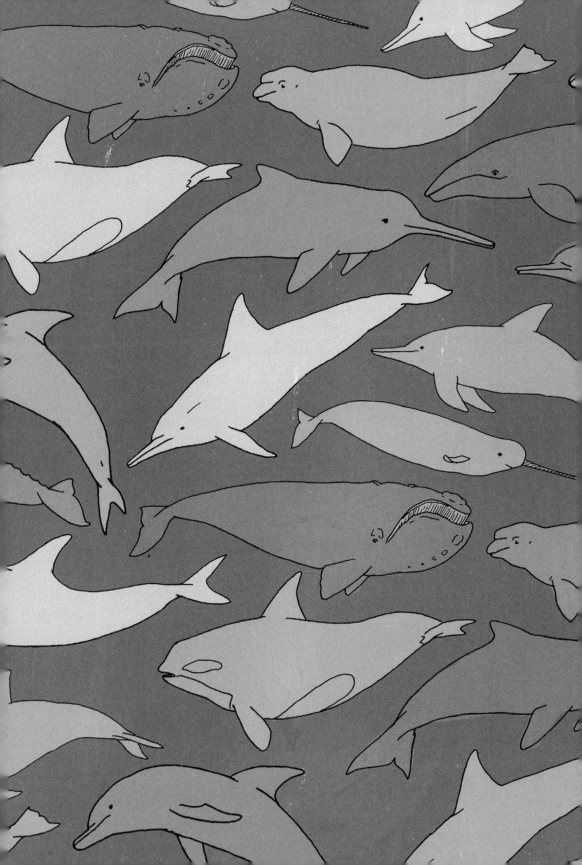

CHAPTER 3

*A Whale of
a Time*

ANATOMY OF A WHALE

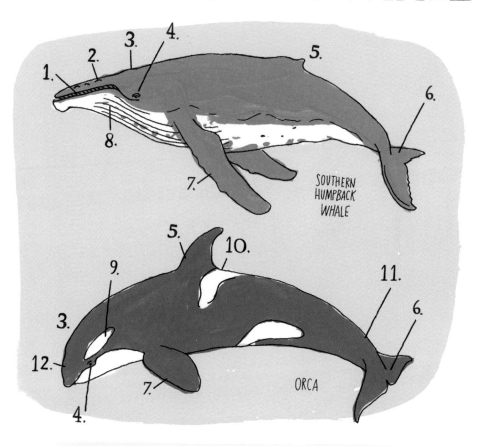

SOUTHERN HUMPBACK WHALE

ORCA

1. baleen
2. tubercules
3. blow hole
4. eye
5. dorsal fin
6. flukes

7. pectoral fin
8. ventral grooves
9. eye patch
10. saddle
11. caudal peduncle
12. rostrum

Whales, dolphins, and porpoises belong to the cetacean [si-TEY-shuhn] family. These air-breathing mammals have modified nostrils, called blowholes, on top of their heads. Their horizontal tail fins are called flukes. All cetaceans have a thick layer of blubber under their skin to protect them and keep them warm in the cold depths.

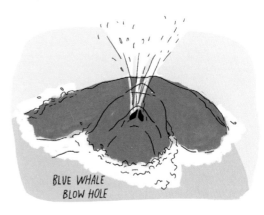

BLUE WHALE
BLOW HOLE

There are more than 80 species of oceanic cetaceans, including 6 porpoise species, more than 30 dolphin species, and more than 40 whale species.

The two major categories of whales are baleen and toothed.

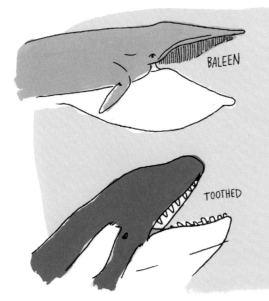

BALEEN

TOOTHED

Baleen whales filter ocean water through large, frilled plates in their mouths, trapping plankton and krill to eat.

Toothed whales hunt for fish, squid, aquatic mammals, and birds.

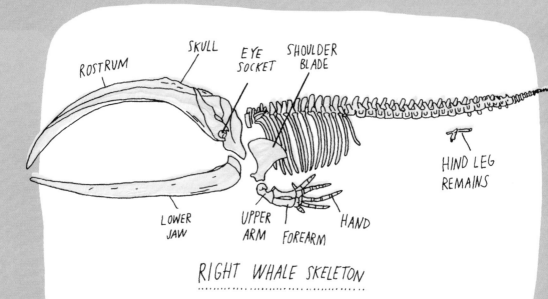

RIGHT WHALE SKELETON

ROSTRUM · SKULL · EYE SOCKET · SHOULDER BLADE · HIND LEG REMAINS · LOWER JAW · UPPER ARM · FOREARM · HAND

Over tens of millions of years, cetaceans evolved from four-legged land mammals. Whales still have bones inside their lower abdomens that are the remnants of rear limbs.

The blue whale is the largest animal ever to have lived on this earth.

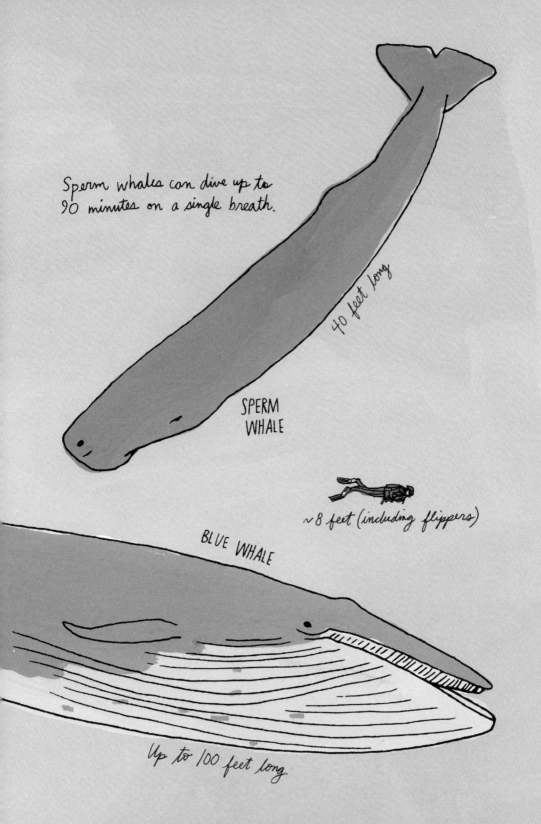

Sperm whales can dive up to 90 minutes on a single breath.

40 feet long

SPERM WHALE

~8 feet (including flippers)

BLUE WHALE

Up to 100 feet long.

WHALES BIG AND SMALL

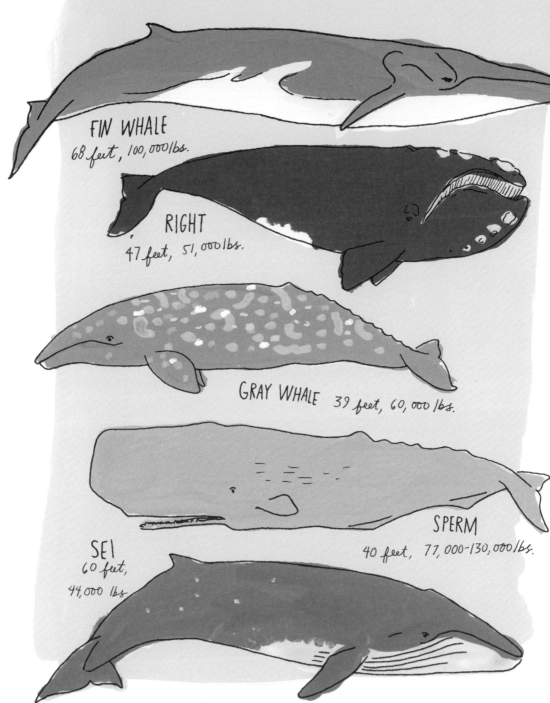

FIN WHALE
68 feet, 100,000 lbs.

RIGHT
47 feet, 51,000 lbs.

GRAY WHALE 39 feet, 60,000 lbs.

SPERM
40 feet, 77,000-130,000 lbs.

SEI
60 feet,
44,000 lbs.

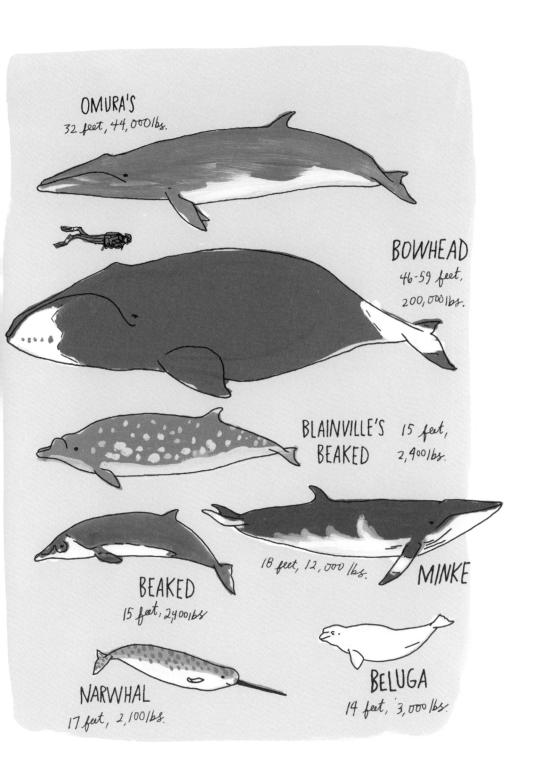

OMURA'S
32 feet, 44,000 lbs.

BOWHEAD
46-59 feet,
200,000 lbs.

BLAINVILLE'S
BEAKED 15 feet,
 2,900 lbs.

18 feet, 12,000 lbs. MINKE

BEAKED
15 feet, 2,900 lbs.

NARWHAL
17 feet, 2,100 lbs.

BELUGA
14 feet, 3,000 lbs.

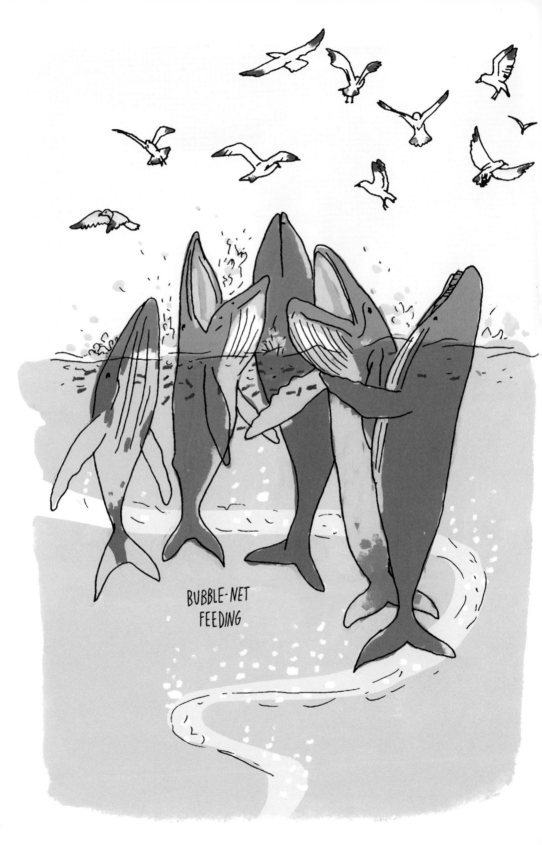

BUBBLE-NET
FEEDING

BUBBLE-NET FEEDING

Humpback whales spend 90 percent of their time feeding, consuming about 5,000 pounds of fish each day when preparing for long migrations.

Their complex and collaborative social structure comes into play in an impressive display of cooperative hunting. Groups of up to 60 humpbacks circle a school of small fish from below. The whales exhale through their blowholes to create a "net" of bubbles that disorients the fish and traps them in a tight ball.

The whales then give a vocalization to start feeding and in perfect unison quickly swim up toward the fish with their mouths open. Using this technique, humpbacks can gather hundreds of pounds of fish with a single gulp of their enormous mouths.

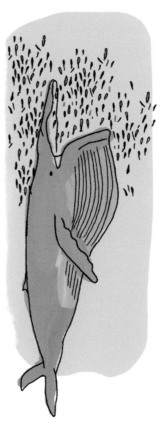

AMBERGRIS: a gray, smelly, waxlike substance. Sperm whales produce ambergris in their stomachs to protect them from sharp cuttlefish beaks. Ambergris, used in perfume making, is very rare and sells for up to $10,000 per pound.

ANATOMY OF A DOLPHIN

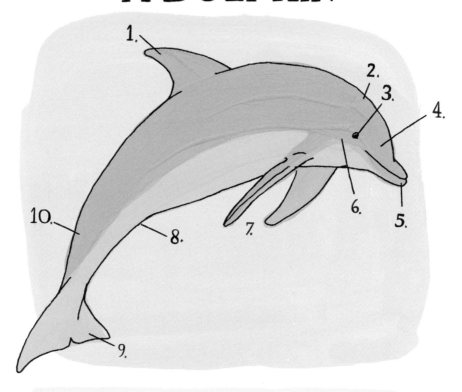

1. dorsal fin
2. blowhole
3. eye
4. melon
5. rostrum

6. ear
7. Pectoral fins
8. genitals
9. fluke
10. peduncle

Frolicking in the surf or leaping in unison through a boat's wake, dolphins are among the ocean's most playful inhabitants.

Dolphins have large brains and display behaviors we associate with intelligence. Members of a pod have been shown to call each other by name, empathize with each other, grieve deaths, form alliances, save surfers from shark attacks, use tools, babysit, and even tease each other.

A group of dolphins, called a pod, is a complex social system. Dolphins pass skills and information across generations. For example, mother dolphins in some pods teach their daughters to protect their noses with sea sponges while digging in the rough seafloor.

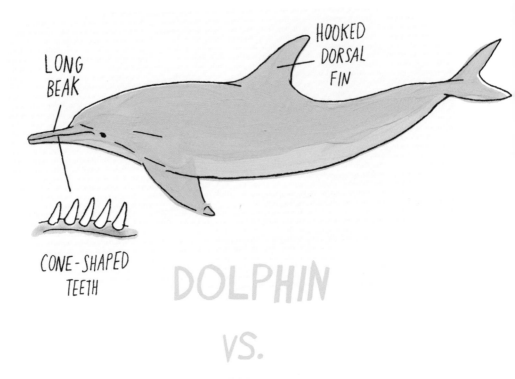

LONG BEAK

HOOKED DORSAL FIN

CONE-SHAPED TEETH

DOLPHIN

VS.

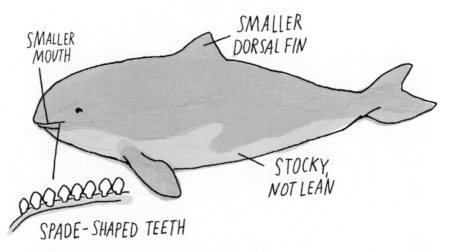

SMALLER MOUTH

SMALLER DORSAL FIN

STOCKY, NOT LEAN

SPADE-SHAPED TEETH

PORPOISE

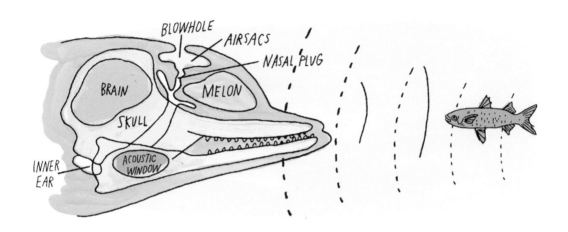

ECHOLOCATION

Dolphins send high-pitched sounds out through their sinus passages and then interpret the echoes to "see" their surroundings. They use this biological sonar to echolocate and identify prey, predators, and other members of their pod. This sonar is so powerful and precise that dolphins can determine the size, shape, and speed of prey and see through solid objects; they can even tell when a member of their pod is pregnant.

Dolphins are chatty with each other. They communicate using a complex system of whistles, clicks, and grunts. They also use touch and body position to make a point.

Most dolphin species eat fish, squid, and seafloor invertebrates. Larger species may feed on aquatic mammals like seals and even whales.

DOLPHIN SPECIES

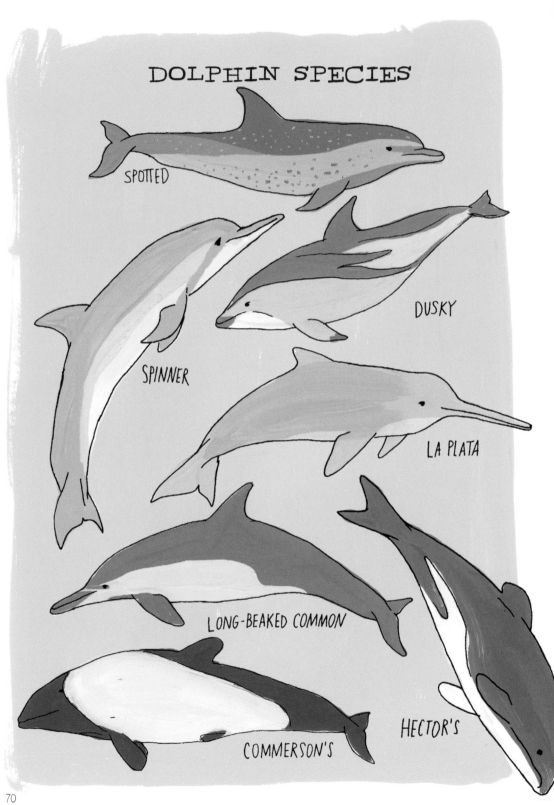

SPOTTED

SPINNER

DUSKY

LA PLATA

LONG-BEAKED COMMON

COMMERSON'S

HECTOR'S

These six species are commonly called whales or blackfish, but genetically they are dolphins.

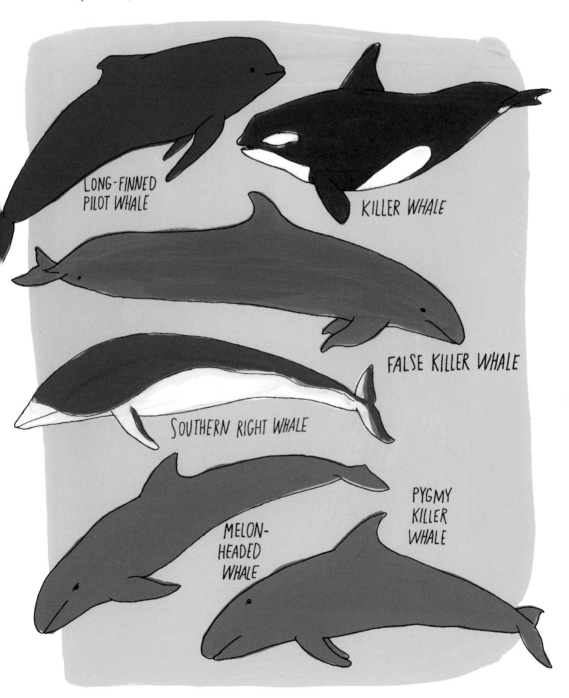

LONG-FINNED PILOT WHALE

KILLER WHALE

FALSE KILLER WHALE

SOUTHERN RIGHT WHALE

MELON-HEADED WHALE

PYGMY KILLER WHALE

ORCAS

Orcas, or killer whales, are the largest members of the dolphin family, with males measuring 25 feet long or more and weighing 13,000 pounds. Orcas are highly adaptable and live in all the world's oceans. Depending on the location and habits of a particular population, orca may feed on fish, seals, squid, turtles, seabirds, and even whales. Pods living in disparate regions vary in coloration, size, fin shape, and markings.

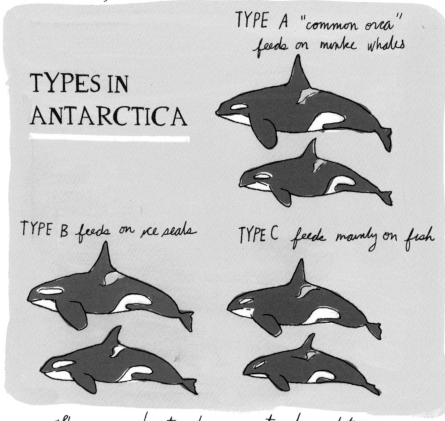

TYPES IN ANTARCTICA

TYPE A *"common orca"* feeds on minke whales

TYPE B *feeds on ice seals*

TYPE C *feeds mainly on fish*

These group hunters have no natural predators.

Orcas can reach speeds of 35 miles per hour in pursuit of prey. They hunt as a team, like wolves, using their keen intelligence to secure food.

Killer whales have never been known to attack humans in the wild.

Pods are organized in line of descent from a female matriarch, who may live 80 years or longer. These are the only mammals known to spend their entire lives with their mothers.

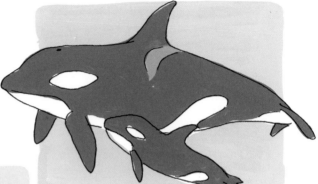

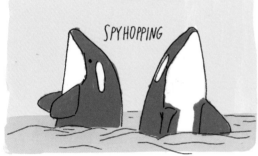

SPYHOPPING

Orcas regularly engage in a unique behavior called spyhopping in which they hold themselves vertically out of the water in order to better see prey above the surface.

Since the 1970s, researchers on the Pacific coast of North America have been tracking orca pods by photographing and identifying the unique shape of each orca's dorsal fin.

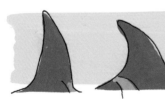

Male orcas have tall, straight dorsal fins while females' fins are curved.

Fins may show evidence of injury from fighting or boat propellers.

A flopped-over fin may indicate illness or advanced age.

THREATENED WHALES

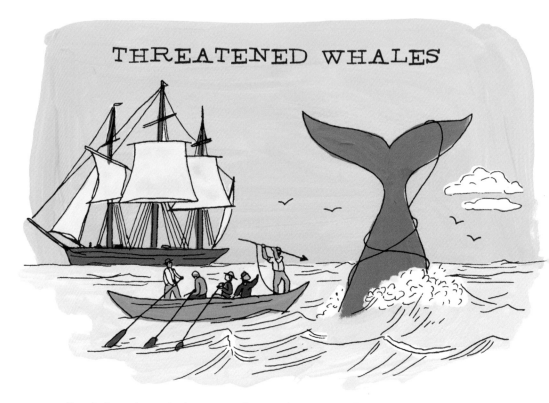

People have hunted whales for thousands of years. Since commercial whaling began in the 18th century, certain whale populations have decreased by more than 90 percent.

Sperm whales, blue whales, and right whales were industrially hunted over 300 years until less than 10 percent of them remained. Humpbacks were hunted down to fewer than 2,000 individuals but are recovering. There may be only 500 North Atlantic right whales left in the wild.

International laws now ban most kinds of whaling, and most whale species are on the rebound, but these creatures still suffer from the effects of humankind on the environment.

THREATS TODAY

POLLUTION

Mercury, petrochemicals, PCBs, and agricultural runoff accumulate in the bodies of fish-eating whales. Some dead beluga whales have been so contaminated by pollution that they have to be treated as toxic waste. All filter-feeding whales consume microplastic along with krill and plankton, threatening their health and reproduction.

CLIMATE CHANGE

As climate change depletes ice cover near the Arctic, humans are opening new shipping lanes and exploring new areas for oil and gas. Whale species that rely on ice cover and quiet feeding grounds, like bowheads and narwhals, are at risk.

SOUND POLLUTION

Since some whales rely on long-distance communication to locate each other for mating, sound pollution from military sonar, shipping, construction, and fossil fuel exploration may put even more pressure on struggling populations.

OVER-FISHING

Humans have over-fished many of the same prey species that toothed whales rely upon. The shrinking chinook salmon population in the US Pacific Northwest has pushed the southern population of resident orcas to fewer than 75 individuals. Whales are also hit by ships and regularly get caught in fishing nets.

MANATEES

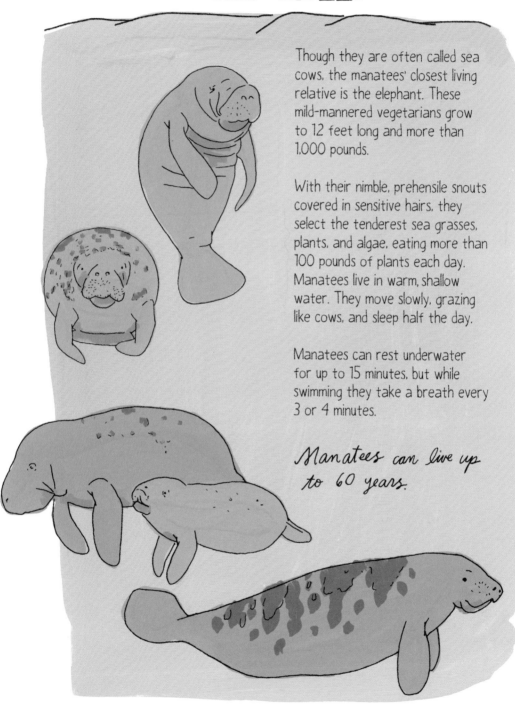

Though they are often called sea cows, the manatees' closest living relative is the elephant. These mild-mannered vegetarians grow to 12 feet long and more than 1,000 pounds.

With their nimble, prehensile snouts covered in sensitive hairs, they select the tenderest sea grasses, plants, and algae, eating more than 100 pounds of plants each day. Manatees live in warm, shallow water. They move slowly, grazing like cows, and sleep half the day.

Manatees can rest underwater for up to 15 minutes, but while swimming they take a breath every 3 or 4 minutes.

Manatees can live up to 60 years.

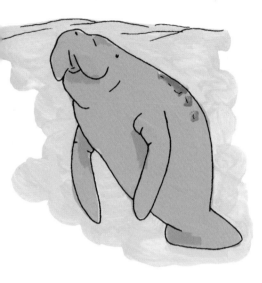

Since manatees spend so much time dozing at the surface, dozens are killed each year in boat collisions. Many survivors have scars on their backs from boat propellers. They also fall victim to fishing nets and poisonous algae blooms known as red tide.

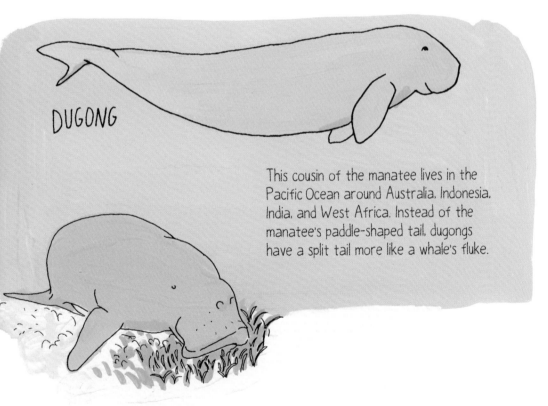

DUGONG

This cousin of the manatee lives in the Pacific Ocean around Australia, Indonesia, India, and West Africa. Instead of the manatee's paddle-shaped tail, dugongs have a split tail more like a whale's fluke.

CHAPTER 4

Life's a Beach

SAND

The minerals that make up sand vary widely from beach to beach.

CORAL ⟶

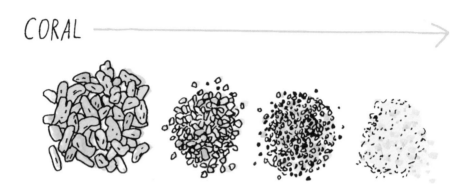

In coastal areas with coral reefs, like the Caribbean, beach sand is composed of tiny particles of coral. Parrotfish feed on the algae inside of coral. These fish create beach sand by grinding up the hard coral in their mouths and throats and excreting the undigested particles.

VOLCANIC ROCK ⟶

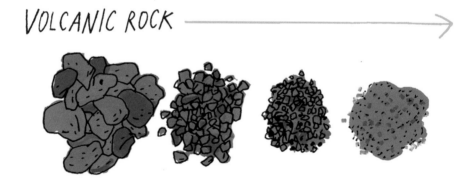

Volcanic sand, found on some Hawaiian beaches, may be black from basalt and obsidian rock that formed inside volcanoes.

The next time you're beachcombing, building a sandcastle, or just lying on the beach soaking up some sun, take a good look at the sand beneath you.

QUARTZ

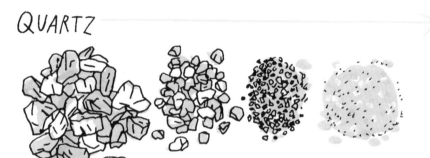

In non-tropical areas, sand tends to be made of silica from wave-beaten quartz stone. Quartz is tough and one of the last minerals to be broken down by the pounding surf.

SEASHELL

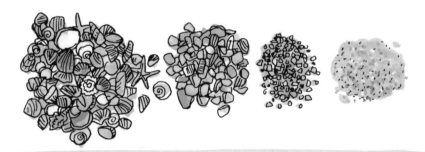

On some beaches, the sand is made entirely of tiny pieces of seashell.

Beach sand is home to many animals.

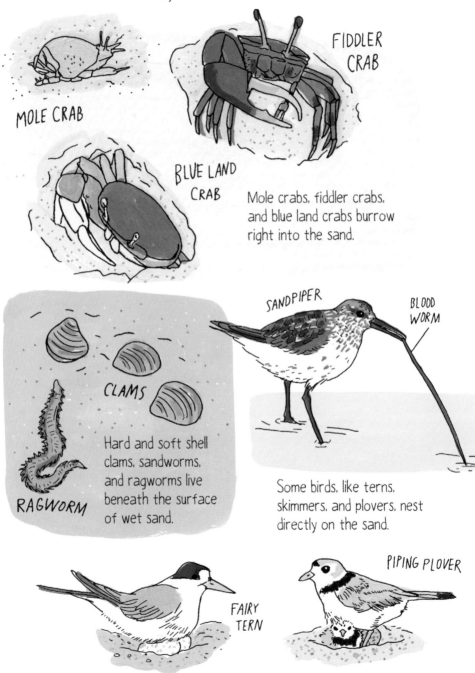

MOLE CRAB

FIDDLER CRAB

BLUE LAND CRAB

Mole crabs, fiddler crabs, and blue land crabs burrow right into the sand.

SANDPIPER

BLOOD WORM

CLAMS

RAGWORM

Hard and soft shell clams, sandworms, and ragworms live beneath the surface of wet sand.

Some birds, like terns, skimmers, and plovers, nest directly on the sand.

PIPING PLOVER

FAIRY TERN

ANATOMY OF A BEACH

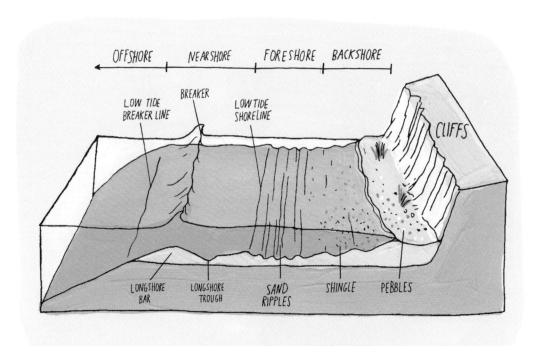

OFFSHORE NEARSHORE FORESHORE BACKSHORE

LOW TIDE BREAKER LINE
BREAKER
LOW TIDE SHORELINE
CLIFFS

LONGSHORE BAR
LONGSHORE TROUGH
SAND RIPPLES
SHINGLE
PEBBLES

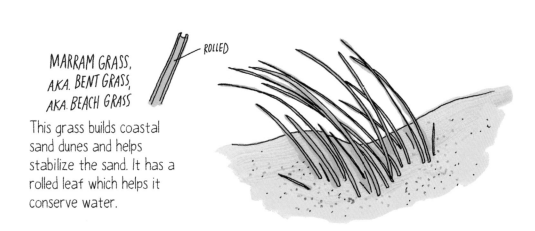

MARRAM GRASS, A.K.A. BENT GRASS, A.K.A. BEACH GRASS

ROLLED

This grass builds coastal sand dunes and helps stabilize the sand. It has a rolled leaf which helps it conserve water.

CALIFORNIA GULL

TIDE POOLS

These natural aquariums allow close-up viewing of beautiful sea creatures that are normally out of reach. Tide pools tend to be best in areas with rocky outcroppings that are only exposed during low tide.

Tide pools host a wide variety of animals that are hardy enough to survive in constantly changing conditions.

Filter feeders like mussels, barnacles, oysters, and brittle stars draw microscopic plankton out of tide pool waters.

BRITTLE STAR

ACORN BARNACLE

BLUE MUSSELS

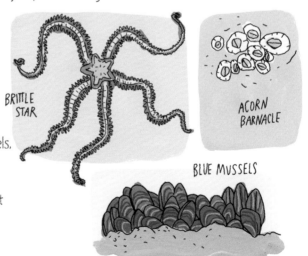

Anemones, sea stars, and crabs feed on snails, molluscs, small crustaceans like copepods, and tiny fish. Abalone love to eat kelp. Snails and limpets scrape algae off of the rocks with coarse, tongue-like organs.

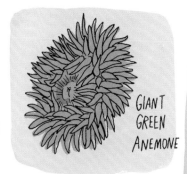

GIANT GREEN ANEMONE

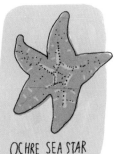

OCHRE SEA STAR

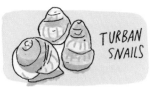

TURBAN SNAILS

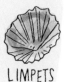

LIMPETS

ABALONE

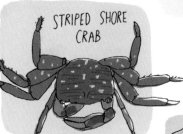

STRIPED SHORE CRAB

Sculpin, opaleye, and even the epaulette shark can be seen darting about after crustaceans, smaller fish, and worms.

OPALEYE

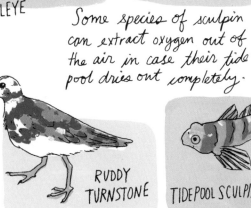

EPAULETTE SHARK

Some species of sculpin can extract oxygen out of the air in case their tide pool dries out completely.

PIED OYSTERCATCHER

Gulls, turnstones, oystercatchers, and other birds pry exposed mussels, limpets, and barnacles from the rocks during low tide.

RUDDY TURNSTONE

TIDEPOOL SCULPIN

TIDAL ZONE ECOSYSTEM

Splash Zone

High Tide Zone

Low Tide Zone

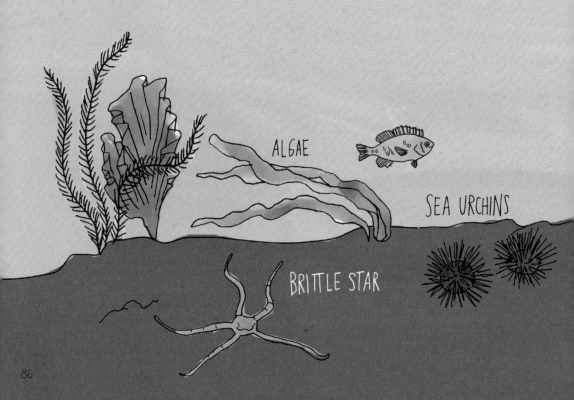

ALGAE

SEA URCHINS

BRITTLE STAR

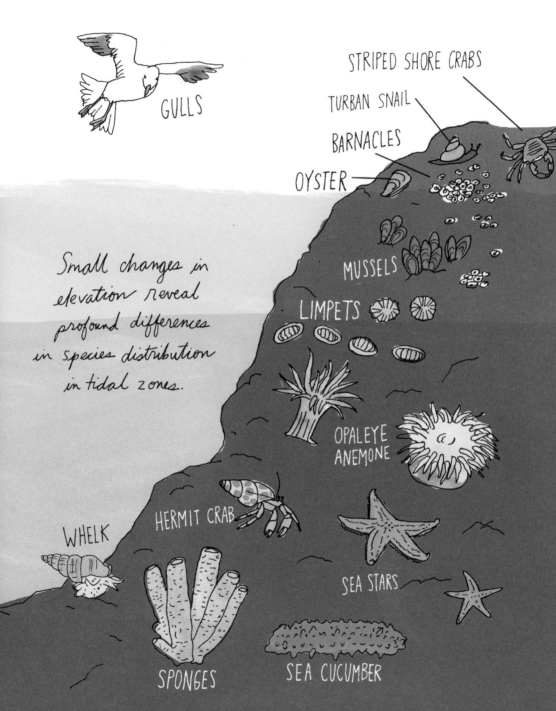

GULLS

STRIPED SHORE CRABS

TURBAN SNAIL

BARNACLES

OYSTER

Small changes in elevation reveal profound differences in species distribution in tidal zones.

MUSSELS

LIMPETS

OPALEYE ANEMONE

WHELK

HERMIT CRAB

SEA STARS

SPONGES

SEA CUCUMBER

SHELL SHAPES

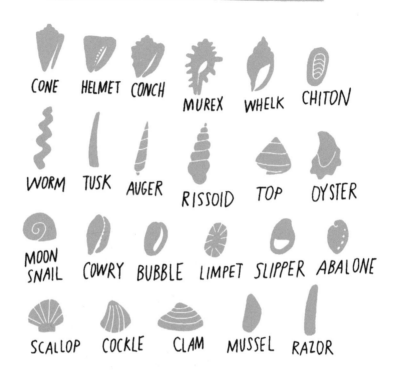

CONE HELMET CONCH MUREX WHELK CHITON

WORM TUSK AUGER RISSOID TOP OYSTER

MOON SNAIL COWRY BUBBLE LIMPET SLIPPER ABALONE

SCALLOP COCKLE CLAM MUSSEL RAZOR

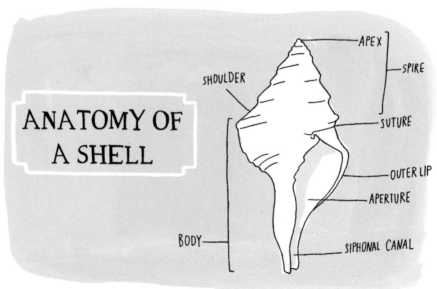

ANATOMY OF A SHELL

APEX
SPIRE
SHOULDER
SUTURE
OUTER LIP
APERTURE
BODY
SIPHONAL CANAL

SO MANY SHELLS

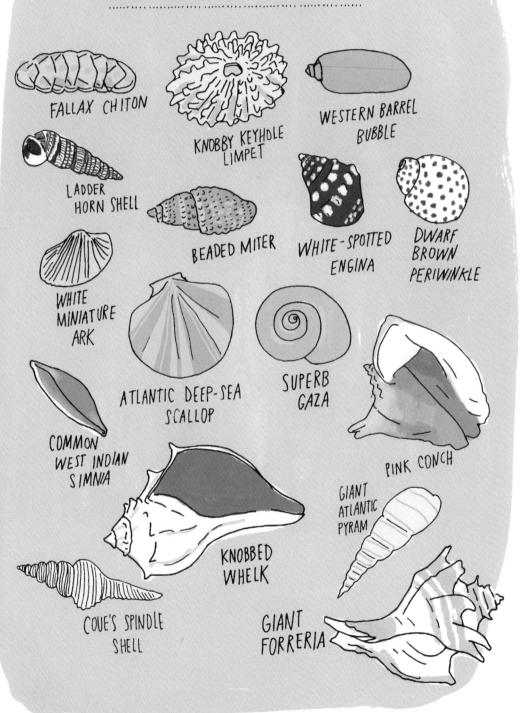

FALLAX CHITON

KNOBBY KEYHOLE LIMPET

WESTERN BARREL BUBBLE

LADDER HORN SHELL

BEADED MITER

WHITE-SPOTTED ENGINA

DWARF BROWN PERIWINKLE

WHITE MINIATURE ARK

ATLANTIC DEEP-SEA SCALLOP

SUPERB GAZA

COMMON WEST INDIAN SIMNIA

PINK CONCH

KNOBBED WHELK

GIANT ATLANTIC PYRAM

COUE'S SPINDLE SHELL

GIANT FORRERIA

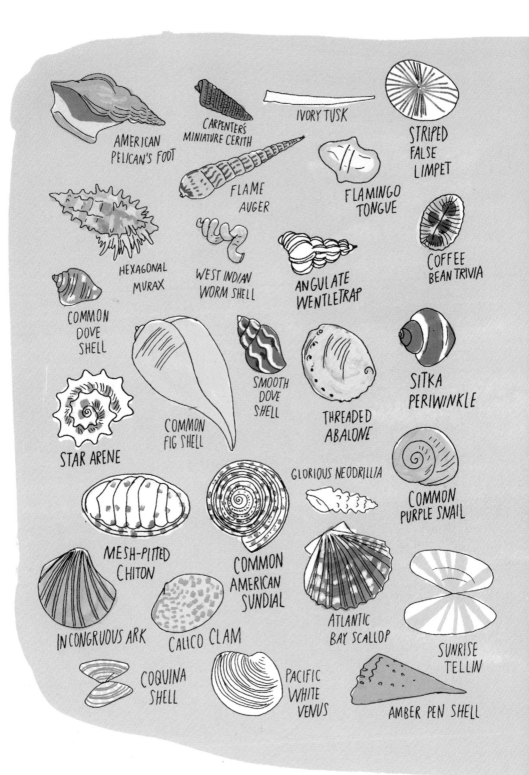

AMERICAN PELICAN'S FOOT

CARPENTER'S MINIATURE CERITH

IVORY TUSK

STRIPED FALSE LIMPET

FLAME AUGER

FLAMINGO TONGUE

HEXAGONAL MURAX

WEST INDIAN WORM SHELL

ANGULATE WENTLETRAP

COFFEE BEAN TRIVIA

COMMON DOVE SHELL

SMOOTH DOVE SHELL

THREADED ABALONE

SITKA PERIWINKLE

STAR ARENE

COMMON FIG SHELL

GLORIOUS NEODRILLIA

COMMON PURPLE SNAIL

MESH-PITTED CHITON

COMMON AMERICAN SUNDIAL

INCONGRUOUS ARK

CALICO CLAM

ATLANTIC BAY SCALLOP

SUNRISE TELLIN

COQUINA SHELL

PACIFIC WHITE VENUS

AMBER PEN SHELL

90

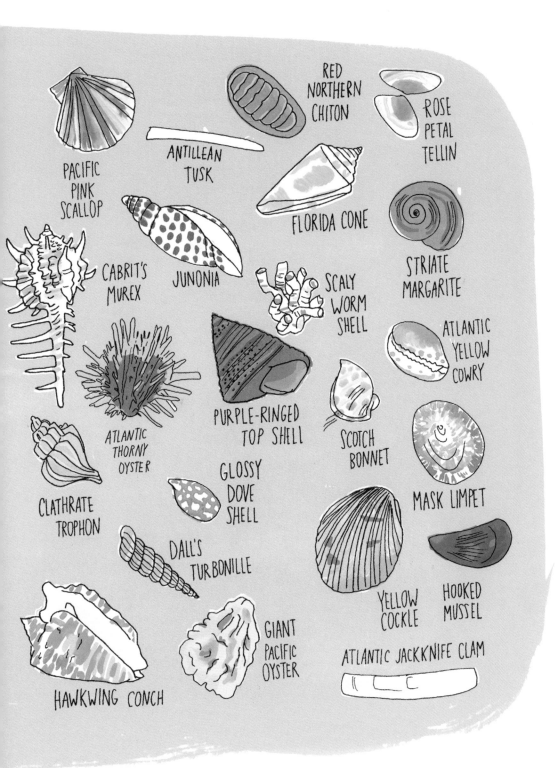

PACIFIC PINK SCALLOP

ANTILLEAN TUSK

RED NORTHERN CHITON

ROSE PETAL TELLIN

FLORIDA CONE

CABRIT'S MUREX

JUNONIA

SCALY WORM SHELL

STRIATE MARGARITE

ATLANTIC YELLOW COWRY

ATLANTIC THORNY OYSTER

PURPLE-RINGED TOP SHELL

SCOTCH BONNET

CLATHRATE TROPHON

GLOSSY DOVE SHELL

MASK LIMPET

DALL'S TURBONILLE

HAWKWING CONCH

GIANT PACIFIC OYSTER

YELLOW COCKLE

HOOKED MUSSEL

ATLANTIC JACKKNIFE CLAM

91

SEAWEED

Seaweed is the common name for more than 10,000 different species of aquatic macroalgae.

Seaweed thrives near shore in rocky, shallow waters all around the world.

Seaweeds are often considered plants because they have chlorophyll and use photosynthesis to create energy from sunlight. However, they don't have true plant structures like leaves, stems, and roots.

Seaweeds are categorized by color: red, brown, and green. These three types of seaweed are only distantly related.

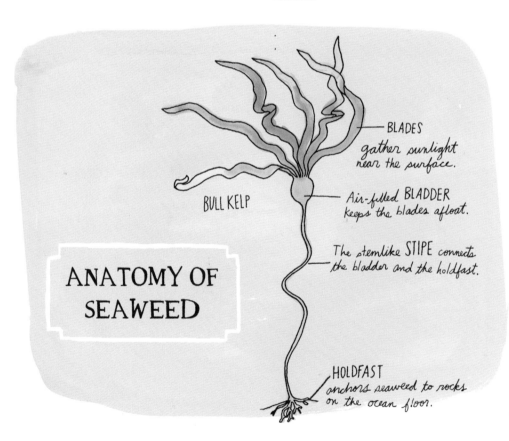

ANATOMY OF
SEAWEED

BULL KELP

BLADES
gather sunlight
near the surface.

Air-filled BLADDER
keeps the blades afloat.

The stemlike STIPE connects
the bladder and the holdfast.

HOLDFAST
anchors seaweed to rocks
on the ocean floor.

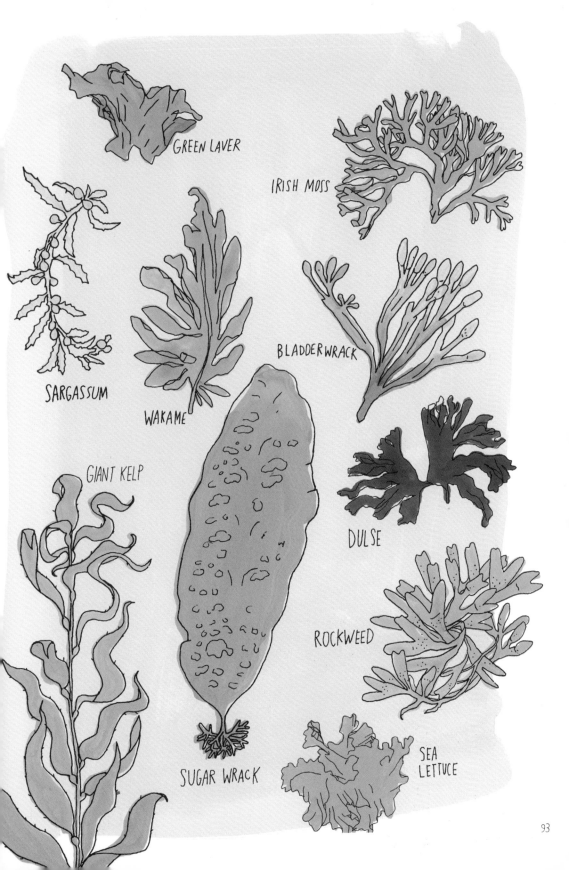

GREEN LAVER

IRISH MOSS

SARGASSUM

WAKAME

BLADDERWRACK

GIANT KELP

DULSE

ROCKWEED

SUGAR WRACK

SEA LETTUCE

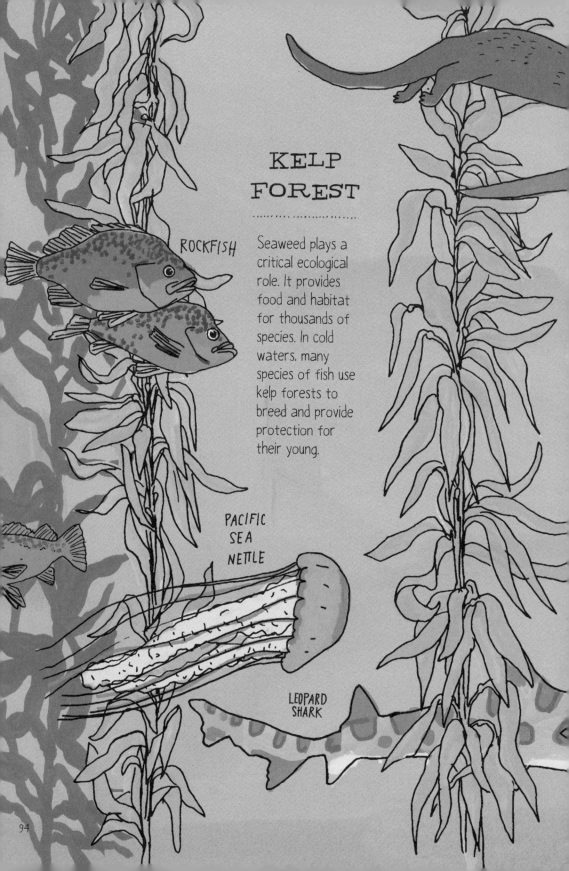

KELP FOREST

Seaweed plays a critical ecological role. It provides food and habitat for thousands of species. In cold waters, many species of fish use kelp forests to breed and provide protection for their young.

ROCKFISH

PACIFIC SEA NETTLE

LEOPARD SHARK

94

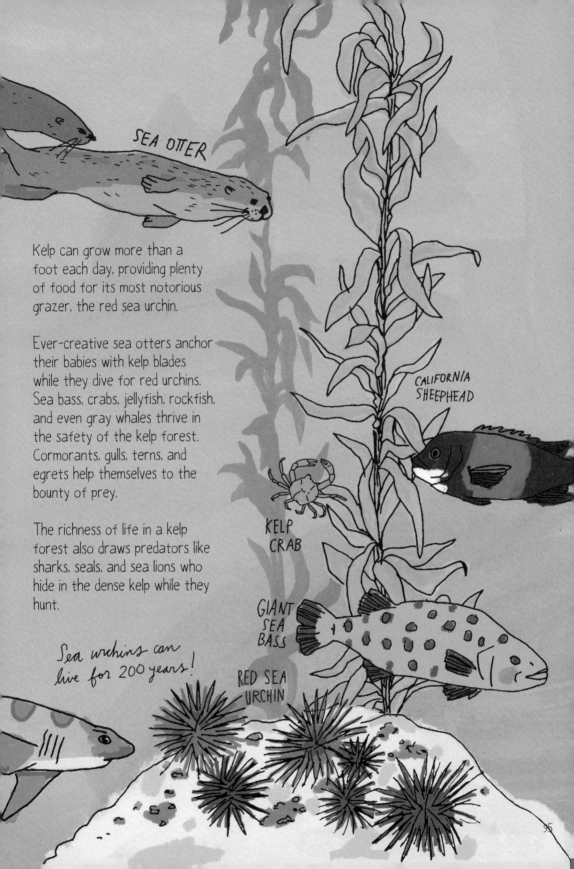

SEA OTTER

Kelp can grow more than a foot each day, providing plenty of food for its most notorious grazer, the red sea urchin.

Ever-creative sea otters anchor their babies with kelp blades while they dive for red urchins. Sea bass, crabs, jellyfish, rockfish, and even gray whales thrive in the safety of the kelp forest. Cormorants, gulls, terns, and egrets help themselves to the bounty of prey.

The richness of life in a kelp forest also draws predators like sharks, seals, and sea lions who hide in the dense kelp while they hunt.

Sea urchins can live for 200 years!

CALIFORNIA SHEEPHEAD

KELP CRAB

GIANT SEA BASS

RED SEA URCHIN

BARNACLES

BALANUS CRENATUS

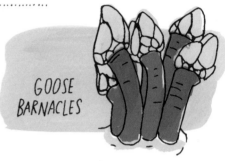

GOOSE BARNACLES

Barnacles tend to live in shallow, tidal areas. They are filter feeders, rhythmically extending their six sets of feathery legs, called cirri, to gather plankton and krill.

TITAN ACORN

Being crustaceans, barnacles are more closely related to crabs and lobsters than they are to mollusks like mussels and oysters.

There are about 1,000 different species of barnacles. Most are hermaphroditic, meaning they have both male and female sex organs.

The barnacle has the longest penis of any animal relative to its size.

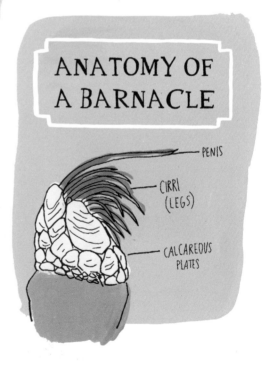

ANATOMY OF A BARNACLE

PENIS

CIRRI (LEGS)

CALCAREOUS PLATES

Some species of barnacles attach themselves to living creatures. The barnacles benefit from increased access to food, but certain hosts, like whales, may be harmed, since the barnacles increase drag and encourage infestations of other parasites.

Barnacles go through two larval stages. Nauplii are tiny, hairy creatures that feed on microscopic plankton. They shed their exoskeletons a few times before arriving at the cyprid stage.

Cyprid larvae do not eat. Their only job is to attach to a safe surface for the rest of their lives. They prefer textured surfaces in rich waters near other barnacles. They grasp the surface with their antennae and cement themselves in place with a protein glue.

Larval barnacles are preyed on by mussels and fish, but only certain whelks and starfish can break through the adults' hard exoskeleton.

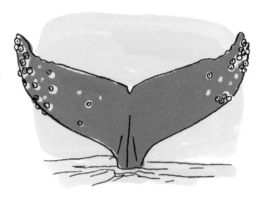

BARNACLES ON WHALE TAIL

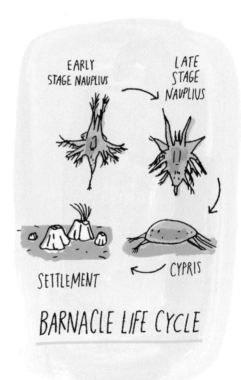

EARLY STAGE NAUPLIUS

LATE STAGE NAUPLIUS

SETTLEMENT

CYPRIS

BARNACLE LIFE CYCLE

RAZOR CLAMS

If you find a small hole in the sand at the waterline that looks like a keyhole, you may be looking at evidence of a buried razor clam.

Razor clams have sharp, narrow, hinged shells. Like all clams, they are bivalves that filter nutrients out of the water.

Razor clams are hard to capture. At the first sign of predators, they quickly dig up to four feet beneath the surface.

Cooked razor clams are considered a delicacy. Some places restrict their collection to avoid exhausting the population.

TYPES OF CLAM SHOWS:

DIMPLE DONUT KEYHOLE

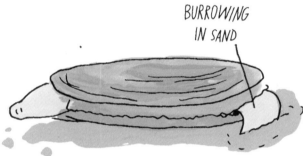

BURROWING IN SAND

PACIFIC RAZOR CLAM

ATLANTIC JACKKNIFE

SPITTING

Shorebirds

GLOSSY IBIS

The nomadic glossy ibis has a wide range that includes Africa, Asia, Australia, and America. Nesting pairs build large platforms of sticks and plants. They feed on many species of insects as well as molluscs and crustaceans.

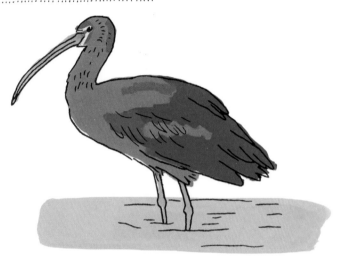

GREEN HERON

Green herons feed on fish, amphibians, and invertebrates, using twigs, insects, feathers, and other objects as lures. They are known to drown large frogs to make swallowing them easier.

ROSEATE SPOONBILL

Roseate spoonbills are large pink birds with flat bills. They sweep their wide bills through brackish water to catch fish, insects, small crabs, and amphibians.

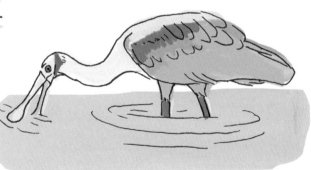

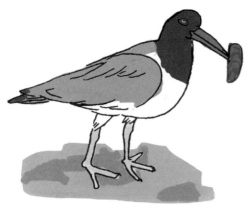

BLACK OYSTERCATCHER

Black oystercatchers live in rocky areas along the Western American coast. Despite their name, they prefer mussels, breaking open the shells with their strong beaks. Oystercatchers often have the same mate for life. When threatened, they whistle loudly and fly off.

SANDPIPER

Common sandpipers range throughout Europe, Asia, Africa, and Australia. They hunt for insects and small crustaceans in shallow water. Sandpipers gather in large groups and give off high-pitched, trilled whistles.

WILSON'S PHALAROPE

When feeding, phalaropes swim in tight circles in shallow water, creating tiny whirlpools to stir up invertebrates from the bottom. Male phalaropes do all the parenting of chicks. Females fight over males and will take multiple male partners each breeding season.

PIED AVOCET

Avocets are easily identified by their whimsically upturned bills. They swing their bills through salt marsh waters to catch insects and krill, a behavior called scything. They nest in large colonies and defend their nests aggressively against intruders.

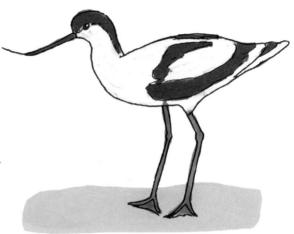

SANDERLING

Sanderlings breed in the Arctic but migrate to locales as far as South America and Australia. Like their sandpiper cousins, they run along the shoreline, following the waves and stopping quickly to pick tiny crabs or horseshoe crab eggs from the sand.

LONG-BILLED CURLEW

Curlews are related to sandpipers. They use their long, curved bills to feed on worms, insects, and crustaceans in mud and soft sand. They are found all over the world.

HERRING GULL

Ocean Birds

ALBATROSS

The great albatross has an 11-foot wingspan, the largest of any bird. It can live more than 40 years. Albatrosses have special shoulder tendons that effortlessly lock their wings open for extremely efficient soaring. Several species of albatross are endangered.

FRIGATEBIRD

Frigatebirds are masters of flight. Their bones make up only 5 percent of their body weight and they have been known to stay aloft for weeks on end, even sleeping in flight. Males inflate their bright red throat pouches to attract females.

WHITE-TAILED TROPICBIRD

Tropicbirds are so well-adapted to life at sea that their legs cannot support them on land. These large birds dive into the ocean to capture flying fish and squid.

BLUE-FOOTED BOOBY

Blue-footed boobies hunt by diving into the sea and then swimming after fish underwater. Boobies are relatively unafraid of humans and frequently land on boats.

BROWN PELICAN

Brown pelicans have a foot-long bill and a 7-foot wingspan. They fly in tight squads just above the ocean's surface. They dive after fish, sometimes capturing several at once in their large throat pouches.

GUILLEMOT

These members of the auk family are poor fliers and walkers, but master swimmers. They propel themselves with their wings, appearing to fly underwater. Some species dive to depths of 300 feet to hunt fish and krill.

INSHORE FISH

Rocks, seaweed, coral, and driftwood in shallow, warm waters near shore provide shelter and forage for many species of resident and migrating fish. If you stand still in the water, or have access to a snorkel and mask, you may glimpse a variety of inshore fish feeding and mating.

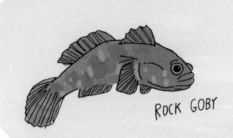

ROCK GOBY

Rock gobies are small, bottom-dwelling fish. Males care for and aggressively defend the eggs females lay under rocks or in empty clam shells. Rock gobies migrated from the Mediterranean Sea to the Red Sea through the Suez canal in 1869.

The long-spined sea scorpion is a kind of sculpin that feeds on blennies, crustaceans, and molluscs. It has no scales, but is armed with spines on its gill plates and bony protuberances on its head and sides. The sea scorpion sinks whenever it stops swimming since it has no buoyant swim bladder.

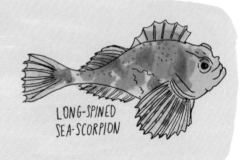

LONG-SPINED
SEA-SCORPION

COMBTOOTH
BLENNIES

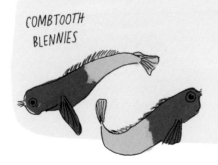

Combtooth blennies are a family of colorful fish that have skin instead of scales. Some blennies use their pectoral fins to "walk" along the bottom. Blennies like tight hiding places; some dig burrows into the sandy bottom or inhabit discarded shells.

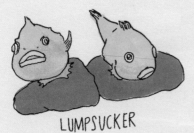

LUMPSUCKER

Lumpsuckers are bizarre, round, little fish that can hardly swim. They have adhesive disks on their pelvises to suction onto rocks. Lumpsuckers feed upon molluscs, worms, and small crustaceans.

Moray eels live in both inshore and deeper waters. They have a secondary set of internal jaws for grasping prey and guiding it down the gullet. Eels have a strong sense of smell and some species secrete a poisonous mucus from their skin. Most moray eels are nocturnal.

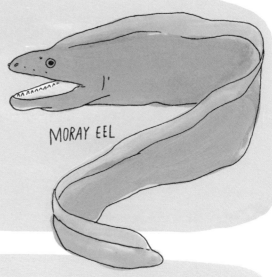

MORAY EEL

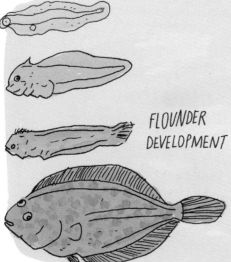

FLOUNDER DEVELOPMENT

Summer flounders lie on the shallow seafloor awaiting prey. They can instantly change the color of their spotted skin to conceal themselves. Every summer flounder lies on its right side; in its larval stage, the right eye migrates to the left side of the head.

ANATOMY OF
A CRAB

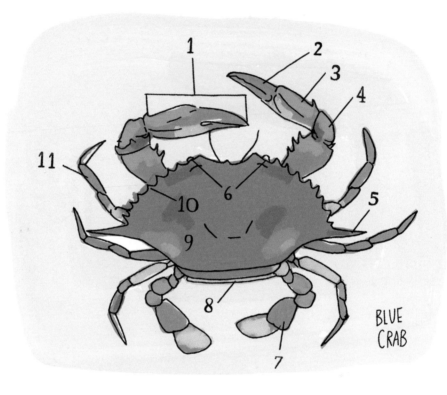

BLUE CRAB

1. chela
2. dactyl
3. propodus
4. carpus
5. lateral spine
6. eyes
7. swimming leg
8. abdominal segment
9. carapace or shell
10. anterolateral teeth
11. pereopod

Crabs are crustaceans that have hard exoskeletons and 10 legs, including their claws. Most of the thousands of species of marine crabs are scavenging omnivores that feed on algae, molluscs, worms, other crustaceans, and any dead animals they come across.

SALLY LIGHTFOOT CRAB

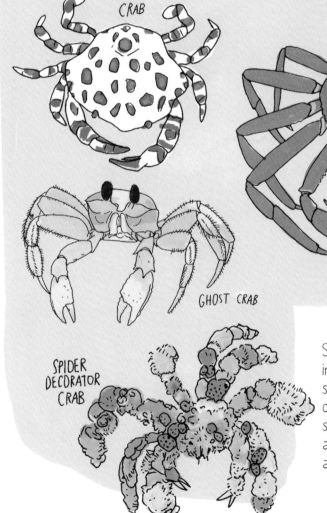

HARLEQUIN CRAB

SNOW CRAB

GHOST CRAB

SPIDER DECORATOR CRAB

Several crab species, including decorator crabs, spider crabs, and masking crabs, camouflage their shells with bits of sponge, algae, and even stinging anemones.

PEA CRAB

TINY

Pea crabs are a parasitic species that live in the gills of oysters and other bivalves.

+GIANT

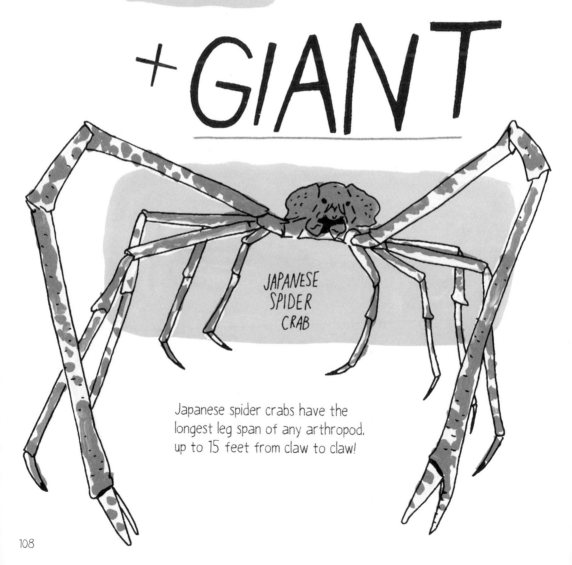

JAPANESE
SPIDER
CRAB

Japanese spider crabs have the longest leg span of any arthropod, up to 15 feet from claw to claw!

Hermit Crabs

Hermit crabs lack hard exoskeletons on their abdomens. They protect themselves by sliding their spiraling hindquarters into the empty shells of marine snails. Occasionally, hermit crabs will also use aluminum cans, plastic containers, nut hulls, or pieces of wood as shells.

As they grow in size, hermit crabs must move into larger shells. In some places, the competition for shells is so intense that crabs line up near a large shell until an appropriately sized crab arrives and discards its own shell in favor of a larger one. Then, in quick succession, the waiting crabs exchange shells, each moving in to a discarded, larger shell.

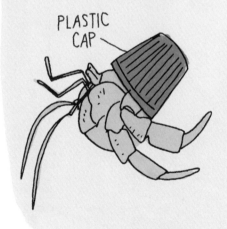

PLASTIC CAP

WITHOUT SHELL

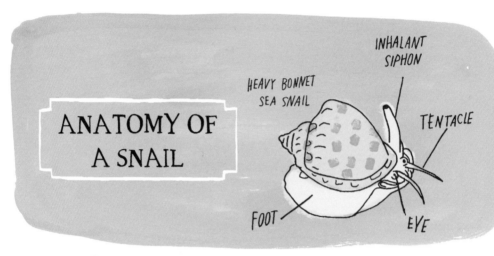

ANATOMY OF A SNAIL

INHALANT SIPHON

HEAVY BONNET SEA SNAIL

TENTACLE

FOOT

EYE

VIOLET SEA SNAIL

TRITON SEA SNAIL

PLOUGH SNAIL

Sea snails are saltwater gastro-pods that can pull their soft bodies into their shells. Most sea snails can completely seal themselves inside their shells with a hard disk on their foot called an operculum.

Snails have a specialized rasping tongue called a radula and eat everything from algae to starfish. The moon snail feeds on clams by drilling through their hard shells with its toothed, belt-like tongue.

CONUS TEXTILE SNAIL

Gastropod means "stomach foot."

MOON SNAIL

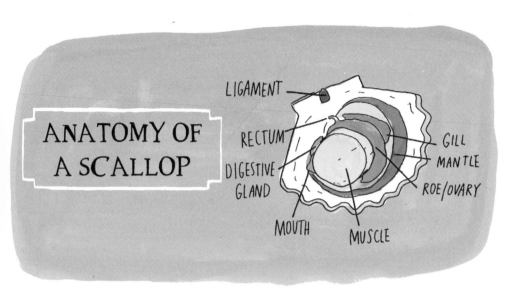

ANATOMY OF A SCALLOP

LIGAMENT
RECTUM
DIGESTIVE GLAND
GILL
MANTLE
ROE/OVARY
MOUTH
MUSCLE

EYES

Scallops are some of the only bivalves that can move freely through the water, living unattached to underwater structures. When a scallop is threatened, it pumps water with its shell and jerkily but quickly swims away.

Though they don't have brains, scallops do have many primitive eyes along the edges of their shells that allow them to sense when predators are near.

CHAPTER 5

Dive In!

THE OCEAN FLOOR

Only about 5 percent of the ocean floor has been well explored. The rest remains an untouched mystery. We do know that an enormous variety of life makes its home on, and even in, the ocean floor.

Depending on the geology of a region, the seabed can comprise sand, rock, clay, or ooze. Almost half of the ocean's floor is covered in ooze made of organic sediments and animal detritus like microscopic shells. In some places, this sediment is several miles thick, which is incredible considering it may take 1,000 years for only two inches of ooze to accumulate!

The famous white cliffs of Dover are the product of millions of years of biological ooze compressing into chalky sediment on the seafloor.

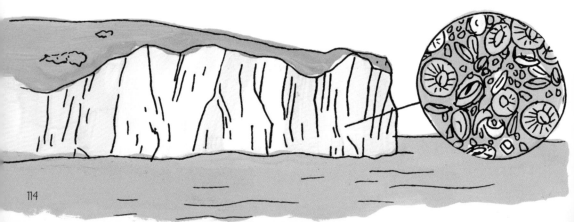

SEA CUCUMBERS

Despite their name, sea cucumbers are animals, not vegetables. They are echinoderms [eh-KIE-no-derms] and related to sea urchins and starfish. Sea cucumbers have calcium nubs just beneath their squishy skin that form a kind of skeleton.

YELLOW SEA CUCUMBER

Sea cucumbers scavenge along the ocean floor feeding on plankton, algae, and tiny animals. Some species bury themselves in the substrate and unfurl branching tentacles to collect food from the water.

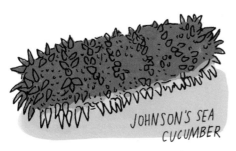

JOHNSON'S SEA CUCUMBER

When attacked, some sea cucumbers push sticky, stinging filaments out of their rear ends.

LEOPARD SEA CUCUMBER

The pearl fish, a long, slender fish species, has evolved the ability to safely live inside a sea cucumber's anus to avoid predators.

Tripod Fish

Tripod fish have pelvic and caudal fins three times the length of their bodies. They stand on these long, rigid fins on the bottom of the ocean waiting in stillness for prey. Tripod fish have poor vision; they wait for tiny fish and crustaceans to bump into their upward-extended pectoral fins before sweeping them into their mouths.

Since they often live alone in the deep ocean, tripod fish can reproduce by fertilizing their own eggs.

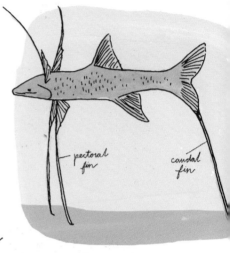

pectoral fin

caudal fin

Hunting Together: Groupers and Moray Eels

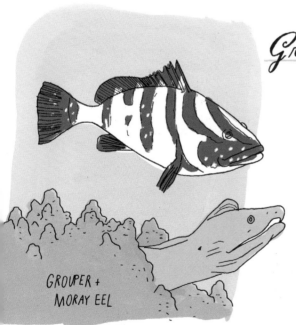

GROUPER + MORAY EEL

Groupers and moray eels live in reefs and rocky areas on the seafloor. Remarkably, instead of competing, these very different predators cooperate to hunt more successfully.

A grouper may shake its head near a moray's burrow to signal it is ready to hunt. The grouper scares fish into crevices that only the moray can access and even points out the spot by going vertical. Similarly, the moray scares prey out of small hiding places for the grouper to gobble up.

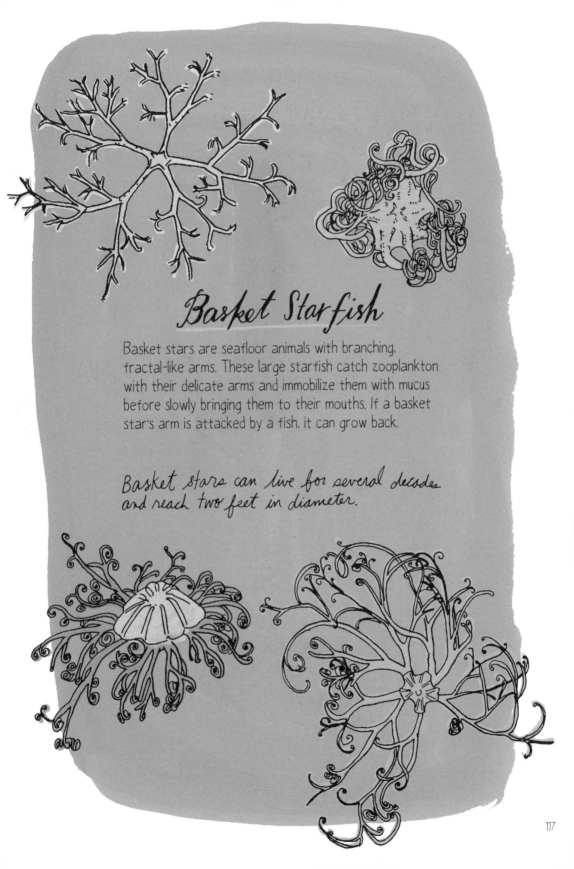

Basket Starfish

Basket stars are seafloor animals with branching, fractal-like arms. These large starfish catch zooplankton with their delicate arms and immobilize them with mucus before slowly bringing them to their mouths. If a basket star's arm is attacked by a fish, it can grow back.

Basket stars can live for several decades and reach two feet in diameter.

ANATOMY OF AN OCTOPUS

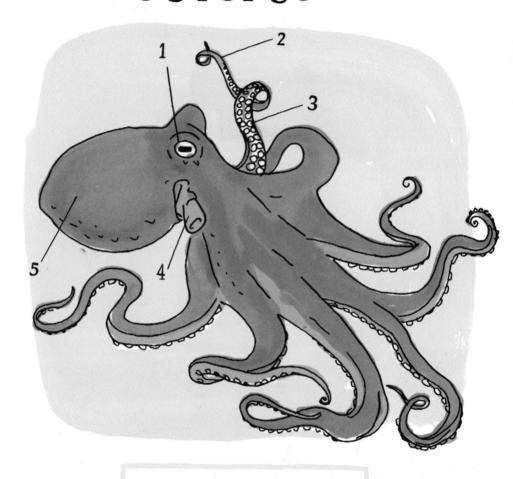

1. eye
2. tentacle
3. sucker
4. siphon
5. mantle

Octopuses have eight nimble arms with two rows of suckers on each limb. They breathe and propel themselves by pushing water through a powerful siphon in their mantles. Their bodies are soft except for a hard beak used to crack open the crabs, bivalves, and other crustaceans they feed upon. Octopuses also have a poison gland that they use to immobilize prey.

To hide from predators, octopuses can change the color and texture of their skin, as well as the shape of their bodies, camouflaging themselves in their surroundings.

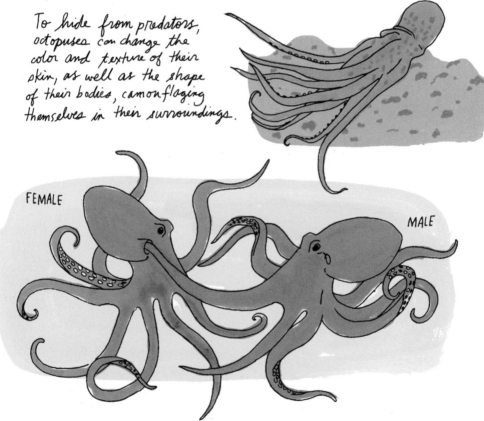

FEMALE

MALE

Octopuses live in all the world's oceans, preferring reefs and rocky areas near the bottom where they rest in dens when not actively feeding. They breed only once in their one-to-five-year life span. The male uses a specialized arm to deliver a packet of sperm to the female and dies soon after.

Female octopuses are exceptionally attentive mothers. They attach their more than 100,000 eggs to the inside of their den and gently blow fresh water over them for months, during which they never leave, not even to eat. Mother octopuses die shortly after their young hatch.

Octopuses display behaviors associated with advanced animal intelligence. In captivity, they are notorious escape artists, pushing their entire bodies through any hole larger than their beaks. Octopuses can unscrew lids and open latches, and have been known to prey on creatures in neighboring tanks and return to their own enclosures.

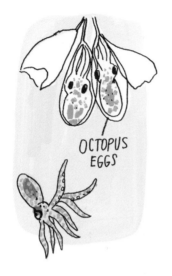

OCTOPUS EGGS

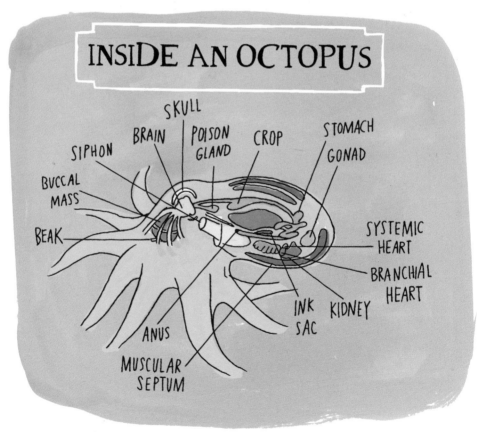

INSIDE AN OCTOPUS

SKULL
SIPHON BRAIN POISON CROP STOMACH
 GLAND GONAD
BUCCAL
MASS
BEAK
 SYSTEMIC
 HEART
 BRANCHIAL
 HEART
 INK KIDNEY
 SAC
ANUS
MUSCULAR
SEPTUM

Squid vs. Cuttlefish

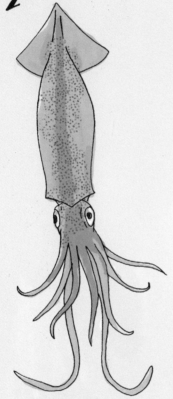
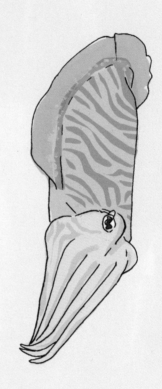

- roundish pupil
- elongated, slender body
- fins near end of mantle
- internal, translucent, flexible "pen" structure
- fast movement
- live in open water

- W-shaped pupil
- bulky, wider body
- fins entire length of mantle
- brittle, internal bonelike structure
- slower movements
- live near the bottom

SQUID

Squid have two long, barbed tentacles and eight smaller arms lined with suction cups. They use their large eyes to find fish and crustaceans. Many squid species also prey upon their own kind.

Squid use the jet propulsion of their siphons as well as the flapping of their head fins to move quickly through the water. Some squid are only one inch long, while the colossal squid may grow to more than 40 feet, making it the largest invertebrate animal.

Squid are social animals, sometimes swimming together in shoals of many thousands. They communicate courtship and hunting signals by flashing changes of skin color. They also use their color-changing ability to hide from predators and camouflage themselves from prey.

The eyeballs of the colossal squid are the largest of any animal.

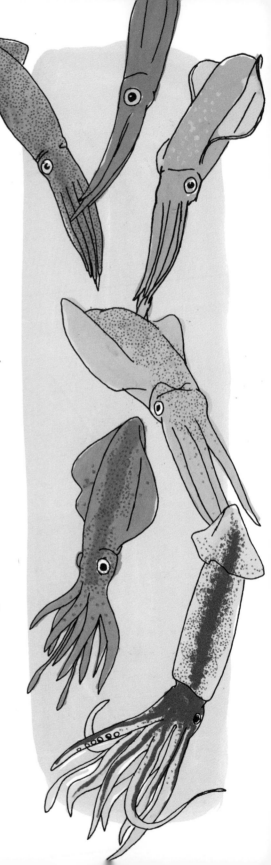

CUTTLEFISH

Cuttlefish are a slower cousin of the squid that have an extraordinary ability to communicate through changes in skin color, texture, and body shape. Cuttlefish can produce pulsating lines and strobes; can become prickly, coral-shaped, or smooth; and can send different messages on different sides of their bodies at the same time. Males can even make themselves look like females to trick larger males.

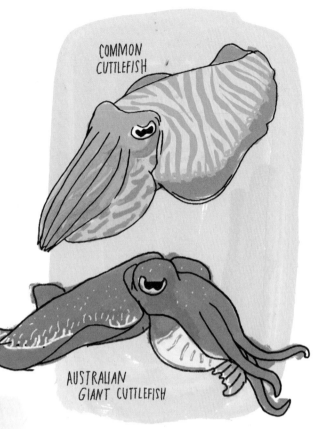

COMMON CUTTLEFISH

AUSTRALIAN GIANT CUTTLEFISH

NAUTILUS

The six known species of nautilus have remained largely unchanged for hundreds of millions of years. Unlike other cephalopods, nautiluses have a large, external shell that protects them and controls their buoyancy in the water.

Pearls

A pearl forms inside a shelled mollusk when its flesh is injured or when a small irritant, like sand, becomes trapped inside its shell. The mollusk builds up layers of shiny nacre, the same hard, iridescent substance that lines the inside of its shell and that we call mother-of-pearl.

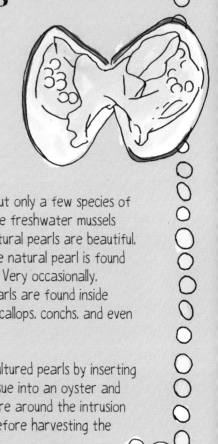

All mollusks with shells can form pearls, but only a few species of marine pearl oysters (Pteriidae) and some freshwater mussels produce true gemstone pearls. These natural pearls are beautiful, valuable, and quite rare; typically only one natural pearl is found per thousand oysters. Very occasionally, interesting natural pearls are found inside giant clams, abalone, scallops, conchs, and even large marine snails.

Humans also create cultured pearls by inserting a bead or a bit of tissue into an oyster and allowing it to build nacre around the intrusion for a year or more before harvesting the shiny results.

The largest natural pearl ever found, the Pearl of Puerto, is oddly shaped and weighs more than seventy pounds!

PEARL OF PUERTO

ANATOMY OF A LOBSTER

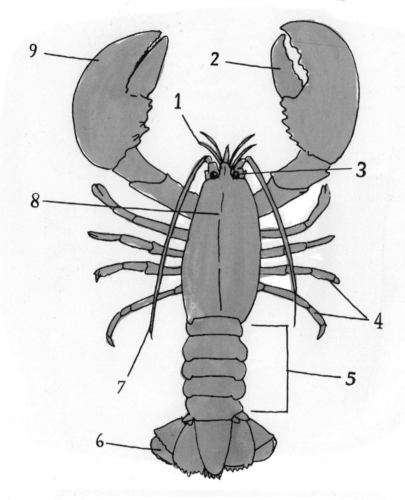

1. antennule
2. pincher claw
3. eye
4 walking legs
5. abdomen

6. tail fin
7 antenna
8. carapace
9. crusher claw

LOBSTERS

These large crustaceans have ten legs, three pairs of which have claws. Their powerful tails are also their abdomens. They are nocturnal and feed upon fish, mollusks, worms, other crustaceans, and algae.

Lobsters can live for decades under good conditions.

The young go through several larval stages before taking on their typical appearance. Lobsters never stop growing, shedding their exoskeletons a few dozen times in their lives. They will often eat their old shells after molting.

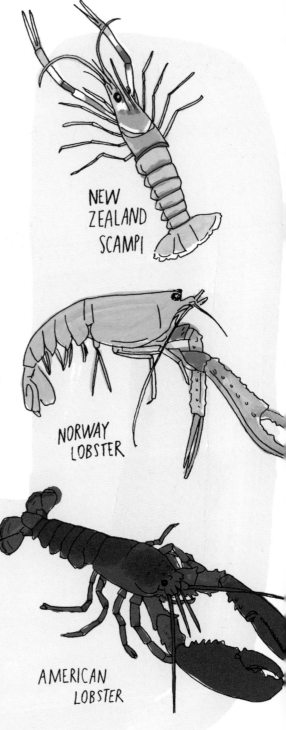

NEW ZEALAND SCAMPI

NORWAY LOBSTER

ROSY LOBSTERETTE

AMERICAN LOBSTER

SHRIMP & PRAWNS

Shrimp and prawns are the general names for many species of ten-legged, swimming crustaceans with strong tails. They range in size from the tiny ¼-inch emperor shrimp to the footlong giant tiger shrimp.

With well-developed eyes situated at the ends of stalks, shrimp have great panoramic vision. They generally have two sets of antennae — a longer pair for navigating the seafloor in the dark and a shorter pair for examining prey.

Pistol shrimp hunt by snapping their claws shut with enough force that the sound stuns their prey.

Shrimp propel themselves with leg-like fins called swimmerets and can also flick their entire tails to quickly dart away from predators.

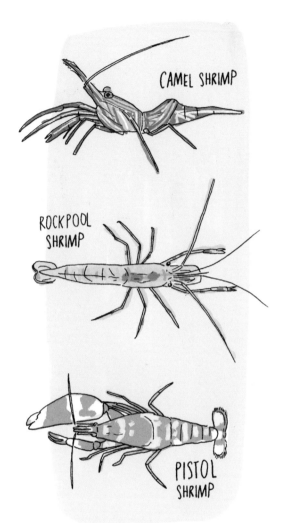

CAMEL SHRIMP

ROCKPOOL SHRIMP

PISTOL SHRIMP

ANATOMY OF A SHRIMP

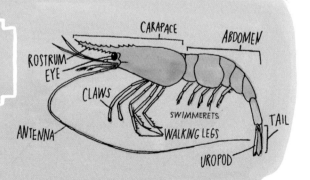

CARAPACE
ABDOMEN
ROSTRUM
EYE
CLAWS
SWIMMERETS
ANTENNA
WALKING LEGS
TAIL
UROPOD

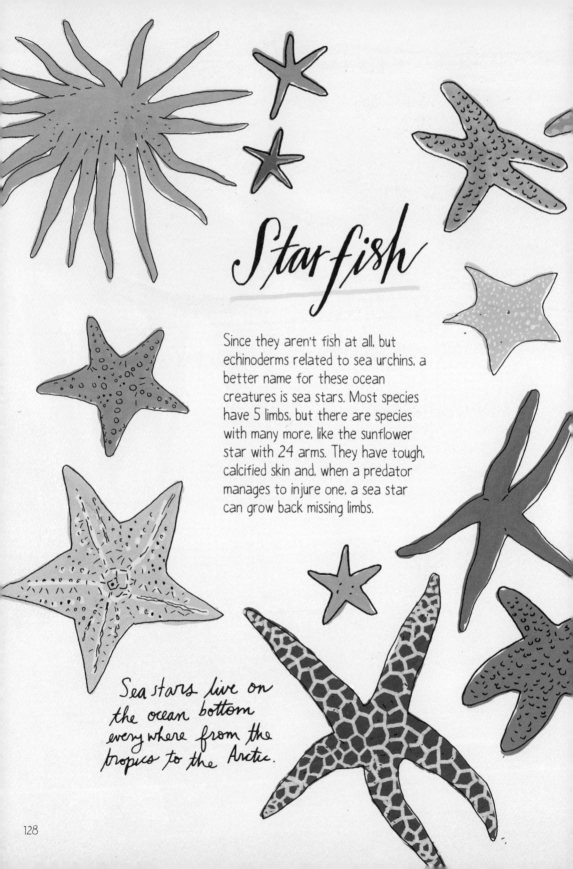

Starfish

Since they aren't fish at all, but echinoderms related to sea urchins, a better name for these ocean creatures is sea stars. Most species have 5 limbs, but there are species with many more, like the sunflower star with 24 arms. They have tough, calcified skin and, when a predator manages to injure one, a sea star can grow back missing limbs.

Sea stars live on the ocean bottom every where from the tropics to the Arctic.

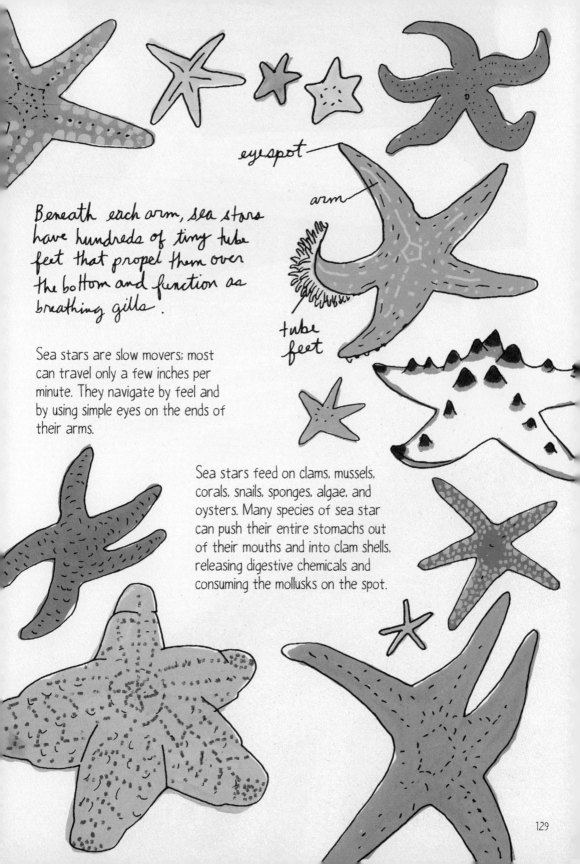

eyespot

arm

Beneath each arm, sea stars have hundreds of tiny tube feet that propel them over the bottom and function as breathing gills.

tube feet

Sea stars are slow movers; most can travel only a few inches per minute. They navigate by feel and by using simple eyes on the ends of their arms.

Sea stars feed on clams, mussels, corals, snails, sponges, algae, and oysters. Many species of sea star can push their entire stomachs out of their mouths and into clam shells, releasing digestive chemicals and consuming the mollusks on the spot.

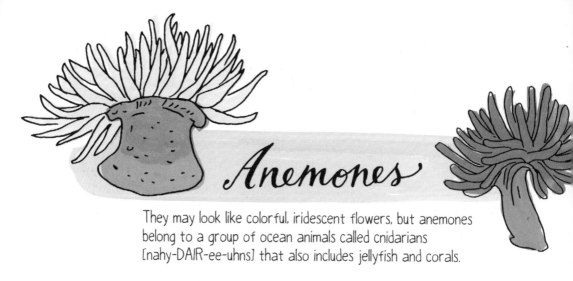

Anemones

They may look like colorful, iridescent flowers, but anemones belong to a group of ocean animals called cnidarians [nahy-DAIR-ee-uhns] that also includes jellyfish and corals.

Many of the 1,000 species of anemones attach themselves to stones, corals, and shells, or bury their feet in the sea bottom, remaining in one spot for a long time. Some slowly walk across the bottom or release themselves completely to roll or float away to better feeding grounds.

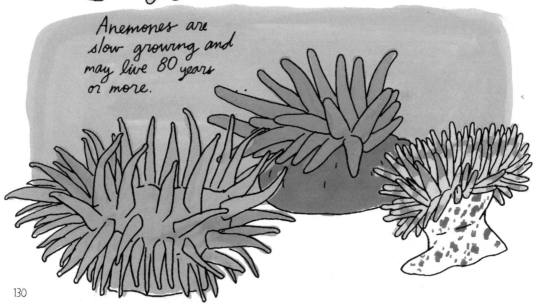

Anemones are slow growing and may live 80 years or more.

In an unusual act of asexual reproduction, an anemone can split off part of its body, forming completely new individuals. Some anemones contain both male and female sexual organs, and some change sex at different times in their lives.

Anemones extend their many tentacles to trap plankton, small fish, crustaceans, and mollusks. Each tentacle is armed with tiny, stinging harpoons, called nematocysts, that immobilize prey and fend off predators. When threatened, anemones can completely retract all of their tentacles into their stalks.

Some anemones absorb algae-containing coral to extract the sugars and oxygen they produce.

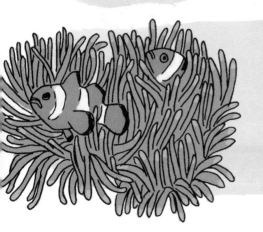

Several animal species besides the clownfish, including some small shrimps and crabs, can live safely among the tentacles of an anemone.

Sea Turtle Identification

AVERAGE LENGTH/WEIGHT	HEAD	CARAPACE
KEMP'S RIDLEY 2 feet / 85 pounds		
OLIVE RIDLEY 2 feet / 80 pounds		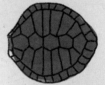
FLATBACK 2.5 feet / 170 pounds	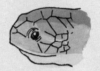	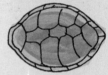
HAWKSBILL 3 feet / 180 pounds	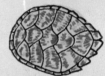	
LOGGER HEAD 3 feet / 300 pounds	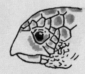	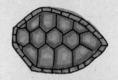
GREEN 5 feet / 350 pounds	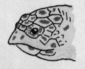	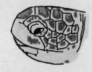
LEATHER BACK 7 feet / 1200 pounds		

SEA TURTLES

Sea turtles are air-breathing reptiles found in all oceans except the cold polar regions. They spend much of their lives at sea migrating long distances.

There are seven species of marine turtle and their diets vary by species:

- Leatherbacks feed on jellyfish.
- Hawksbills mostly eat sponges.
- Juvenile green turtles eat both animals and plants, but adult green turtles only eat seagrass and algae.
- Loggerheads, flatbacks, Kemp's ridleys, and olive ridleys are omnivores that feed upon fish, shrimp, algae, sea cucumbers, mollusks, cnidarians, sea stars, seagrass, and worms.

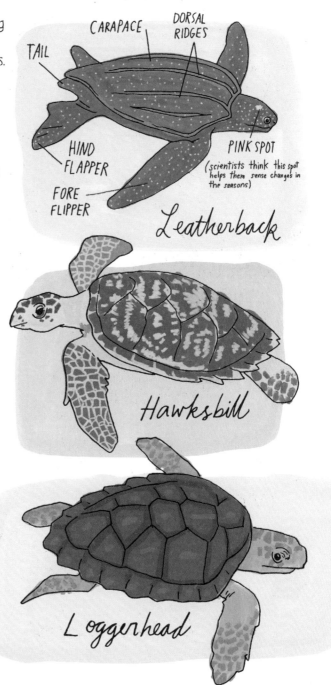

CARAPACE

DORSAL RIDGES

TAIL

HIND FLAPPER

FORE FLIPPER

PINK SPOT
(scientists think this spot helps them sense changes in the seasons)

Leatherback

Hawksbill

Loggerhead

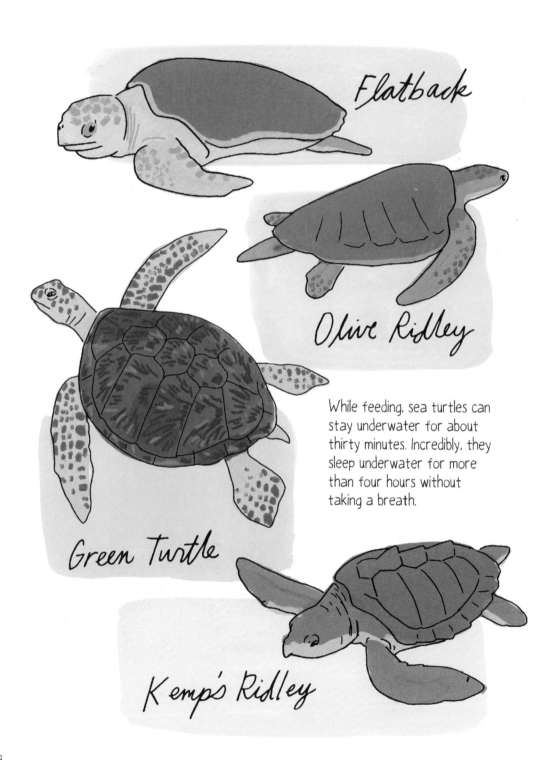

Flatback

Olive Ridley

While feeding, sea turtles can stay underwater for about thirty minutes. Incredibly, they sleep underwater for more than four hours without taking a breath.

Green Turtle

Kemp's Ridley

When a female is ready to lay her eggs, she climbs onto a safe beach at night, digs a hole with her flippers, and lays from 50 to several hundred leathery eggs. She covers the eggs with sand and camouflages the hole so her offspring can safely incubate for 45 to 60 days.

If the beach is warm, more of the hatchlings will be female; if it's cold, more will be male.

The tiny turtles usually hatch at night, digging out of their holes and making a risky dash to the safety of the sea. Hungry birds, crabs, and mammals sometimes consume half of the hatchlings before they make it to the water.

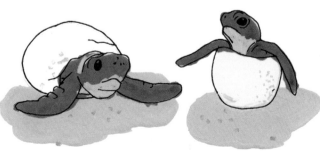

Juvenile turtles live and grow in the open ocean until they reach sexual maturity. At between 15 and 20 years old they move toward coastal areas for breeding.

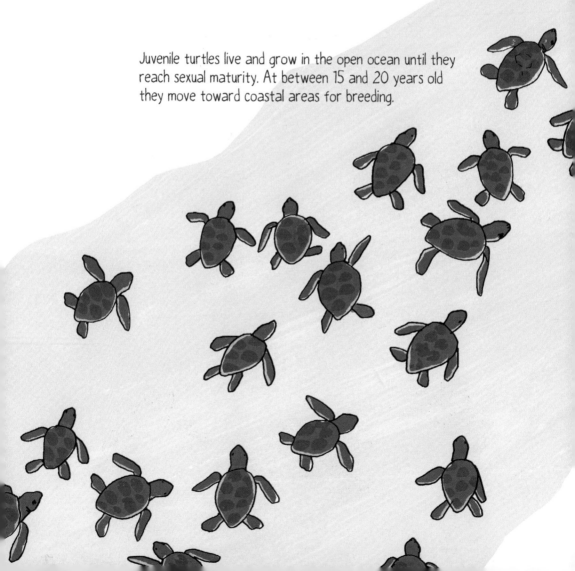

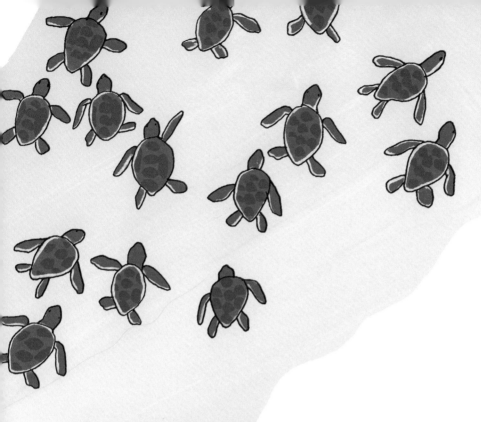

Dolphins, sharks, seabirds, and orcas prey on juvenile and adult turtles. In addition to these risks, the effects of human culture on sea turtles has led six of the seven species to be listed as threatened or endangered. Illegal poaching for meat and shells, entanglement in fishing lines and nets, coastal development, climate change, and pollution contribute to the less than 1 percent survival rate for sea turtle hatchlings.

Great Migrations

Many ocean animals travel long distances to reach prime feeding territories or breeding and spawning grounds. Using electronic tagging and satellites, scientists have tracked individuals of several species to learn the distances and routes they take on their epic journeys.

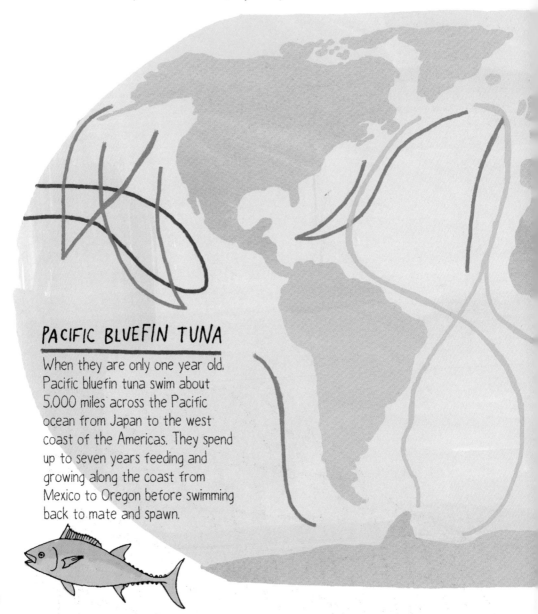

PACIFIC BLUEFIN TUNA

When they are only one year old, Pacific bluefin tuna swim about 5,000 miles across the Pacific ocean from Japan to the west coast of the Americas. They spend up to seven years feeding and growing along the coast from Mexico to Oregon before swimming back to mate and spawn.

HUMPBACK WHALES

The longest mammal migration in the world is undertaken by humpback whales. For much of the year, they feed on krill and small fish in waters too cold to raise their young and must travel to warmer waters near the equator for mating and calving. Humpbacks take very few breaks as they swim 6,000 miles from Antarctica to Costa Rica, or from Alaska to Hawaii, in only five to eight weeks.

ARCTIC TERN

The record-holder for epic migrations is the arctic tern. This seabird has been recorded flying more than 50,000 miles in a single year. Arctic terns travel in a winding course from the Arctic to the Antarctic and back, flying over the open ocean. A tern might cover more than one million miles in its lifetime!

CHAPTER 6

Reef Madness

CORAL REEFS

There are three kinds of reefs: fringing reefs, barrier reefs, and atolls

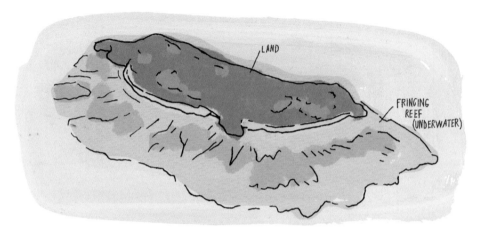

Fringing Reef

Fringing reefs are the most common kind of coral reef. They grow outward from the shoreline, leaving only very shallow water between them and the land.

Barrier Reef

Barrier reefs also grow parallel to the shoreline but have lagoons or areas of deep water between the reef and the land.

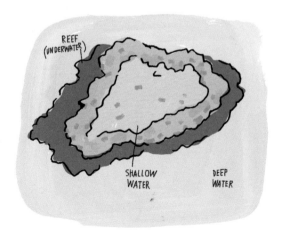

Atoll

An atoll is a ring-shaped island that encloses a lagoon. Over eons, oceanic volcanoes sink back beneath the surface of the water leaving behind the barrier coral reefs that grew up around them. These coral reefs continue to grow faster than the volcanos subside, forming the atoll.

Since corals need warm, clear water to thrive, most atolls are found in the tropical and semi-tropical regions of the Indian and Pacific oceans.

The coral at the outer edge of an atoll's barrier reef typically remains a vibrant ecosystem but the coral on the inside tends to die as the open ocean is sealed off. The magnificent turquoise of the lagoon comes from disintegrating limestone from the ancient reef.

Atolls rarely grow to more than 15 feet above sea level and so are increasingly inundated by rising sea levels.

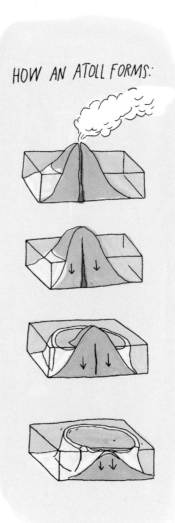

HOW AN ATOLL FORMS:

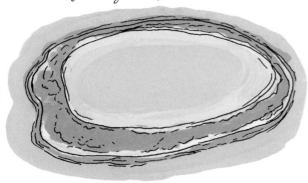

REEF ZONES

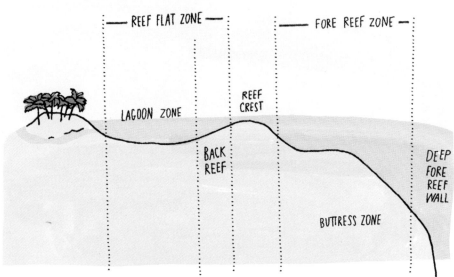

Corals of the same species may take different forms in different zones of the reef.

REEF FLAT The relatively extreme conditions caused by a wide range of temperature, oxygen, sunlight, and salinity means reef flats harbor a lower diversity of life than other areas of the reef.

BACK REEF The back reef is shallow, protected from waves, and may have small patches of living reef and coral rubble.

REEF CREST The reef crest is the highest point of a reef where waves break. The crest may be exposed during low tide and these harsh conditions mean the corals here must be strong and adaptable.

DEEP FORE REEF WALL The ocean-facing side of the fore reef zone can form a vertical wall or drop-off. The greatest diversity of life exists here at depths of 15 to 65 feet.

CORAL POLYPS

A coral polyp is a simple animal less than one tenth of an inch in size. Many thousands of individual coral polyps live together in colonies to form the structures of coral. Each polyp has food-capturing tentacles with stinging cells, a mouth, and digestive filaments.

Coral colonies may be thought of as a single organism since the polyps are connected to each other by very thin bands of living tissue.

Corals harbor tiny plant cells, zooxanthellae algae, in their tissues. Coral and algae are obligatory symbionts, meaning they depend on each other for survival. The coral provides the algae a safe environment and the chemicals they need for photosynthesis. The algae gives the coral the compounds necessary to grow its tissues and skeleton. This beneficial relationship powers the abundant productivity of coral reefs.

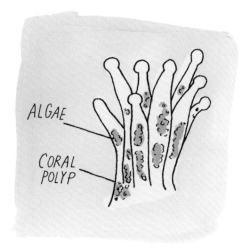

ALGAE

CORAL POLYP

CORAL

There are more than 2,000 different species of coral. About half are stony corals that have hard calcium skeletons, and half are soft corals.

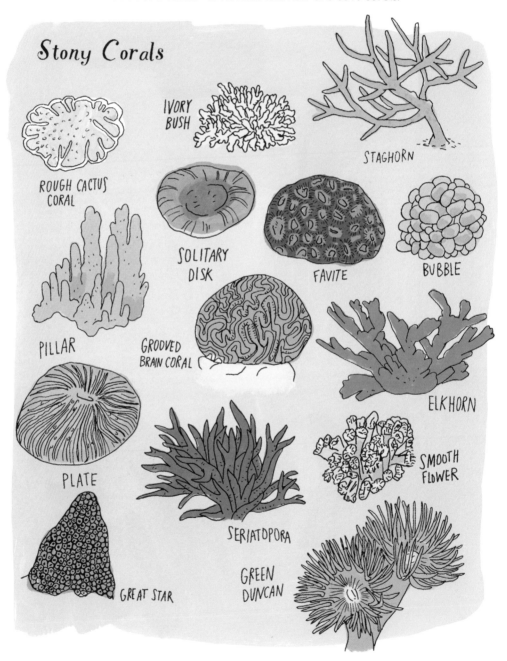

Stony Corals

IVORY BUSH

STAGHORN

ROUGH CACTUS CORAL

SOLITARY DISK

FAVITE

BUBBLE

PILLAR

GROOVED BRAIN CORAL

ELKHORN

PLATE

SMOOTH FLOWER

SERIATOPORA

GREAT STAR

GREEN DUNCAN

Soft Corals

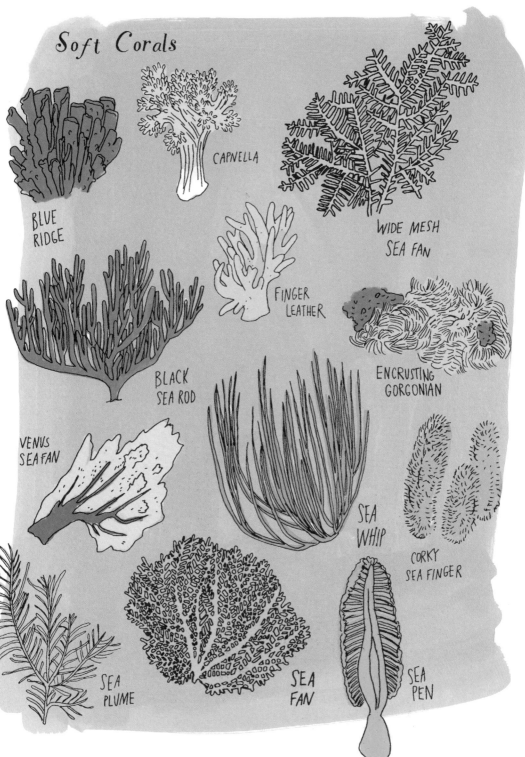

CAPNELLA

BLUE RIDGE

WIDE MESH SEA FAN

FINGER LEATHER

BLACK SEA ROD

ENCRUSTING GORGONIAN

VENUS SEAFAN

SEA WHIP

CORKY SEA FINGER

SEA PLUME

SEA FAN

SEA PEN

FISH IN CORAL REEFS

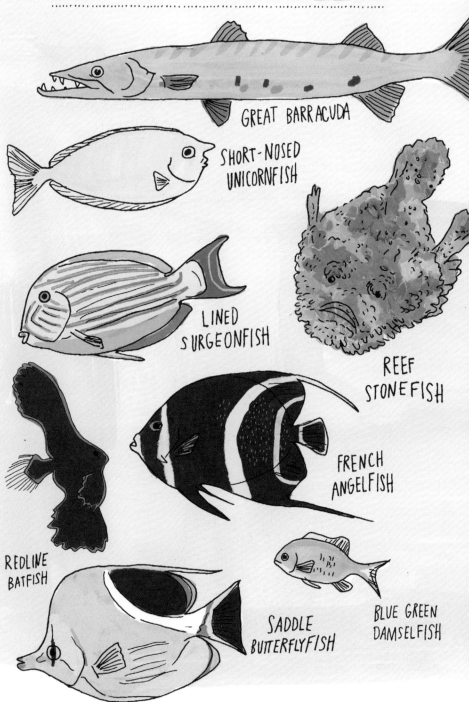

GREAT BARRACUDA

SHORT-NOSED UNICORNFISH

LINED SURGEONFISH

REEF STONEFISH

FRENCH ANGELFISH

REDLINE BATFISH

SADDLE BUTTERFLYFISH

BLUE GREEN DAMSELFISH

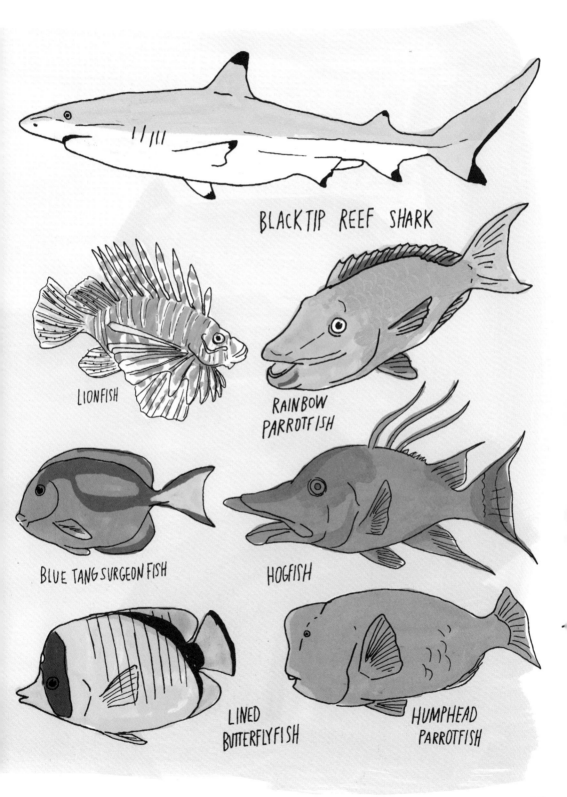

BLACKTIP REEF SHARK

LIONFISH

RAINBOW PARROTFISH

BLUE TANG SURGEON FISH

HOGFISH

LINED BUTTERFLYFISH

HUMPHEAD PARROTFISH

THE GREAT BARRIER REEF

Off the eastern coast of Australia lies the earth's largest natural structure made by animals. The Great Barrier Reef is 1,400 miles long and covers nearly as much area as the state of California. It is the largest coral reef complex that has ever existed on Earth.

This marvel of the natural world hosts an enormous diversity of life including nearly 3,000 species of fish, 215 species of seabirds, 400 species of coral, and hundreds of species of mollusks and seaweed.

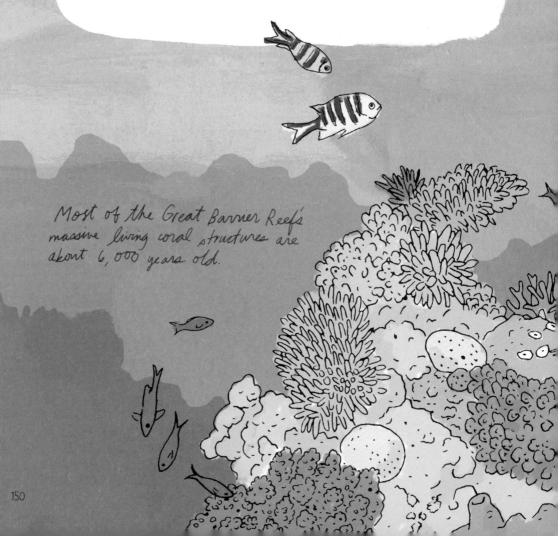

Most of the Great Barrier Reef's massive living coral structures are about 6,000 years old.

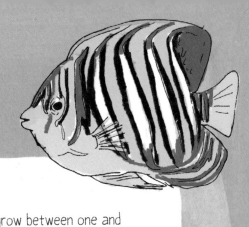

Under ideal conditions reefs can grow between one and nine inches a year. But like many of the world's reefs, the Great Barrier Reef is in trouble. It has lost more than half of its coral since the mid 1980s. Threats include agricultural runoff and over-harvesting of marine life, as well as severe coral bleaching from warming oceans that permanently damages the reef.

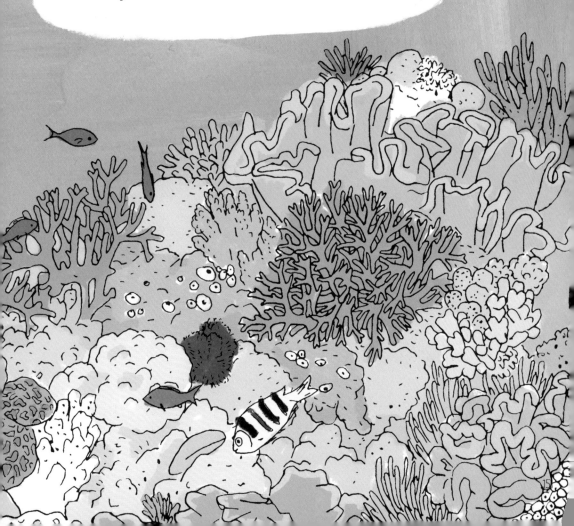

ANATOMY OF A SEAHORSE

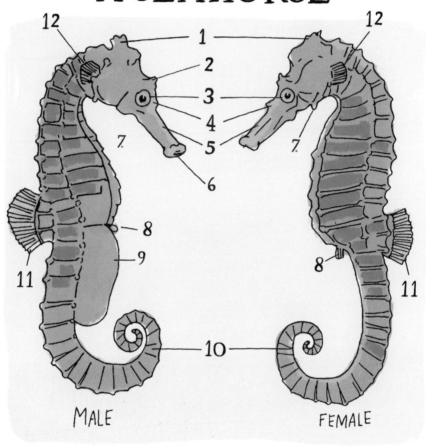

MALE

FEMALE

1. coronet	5. snout	9. brood pouch
2. eye spine	6. mouth	10. tail
3. eye	7. cheek spine	11. dorsal fin
4. nose spine	8. anal fin	12. pectoral fin

Seahorses are small bony fish that swim upright and have skin instead of scales. They use their long snouts to suck up their favorite foods, mysid shrimp and other tiny crustaceans.

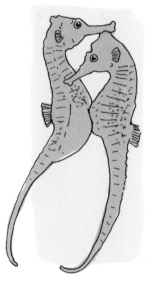

After a lengthy and elaborate courtship that includes synchronized movements, holding tails, color changes, and a spiraling dance, the female seahorse deposits eggs into a pouch on the front of the male's body. The eggs are fertilized inside his pouch and gestate there until dozens of fully formed, but tiny, seahorses are born.

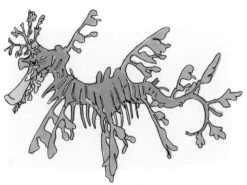

LEAFY SEA DRAGON

The leafy appendages make this fish look like a piece of floating seaweed, disguising it from both predators and prey.

PYGMY SEAHORSE

These species are less than one inch long and perfectly match the color and texture of the corals they live on.

SPONGES

Sea sponges are simple ocean animals that thrive without hearts, brains, or stomachs. Sea water flows through their porous bodies delivering oxygen and the bacteria and plankton they feed upon. Many sponge species float freely in the water column as juveniles but attach permanently to the bottom as adults.

Some shallow-water sponges host algae in their cells and benefit from their ability to make food from sunlight. A few species are even carnivorous, trapping tiny crustaceans in their bodies and consuming them.

Certain sea sponge populations have been damaged by thousands of years of humans harvesting them to use as cleaning tools.

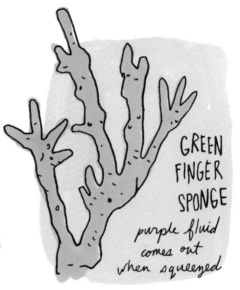

GREEN FINGER SPONGE

purple fluid comes out when squeezed

Even small fragments broken off a sea sponge can regenerate into complete individuals.

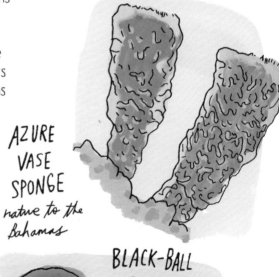

AZURE VASE SPONGE

native to the Bahamas

BRANCHING TUBE SPONGE

lives in the Caribbean, Florida, Bermuda, and the Bahamas

BLACK-BALL SPONGE

found in warm shallow water in the Caribbean Sea

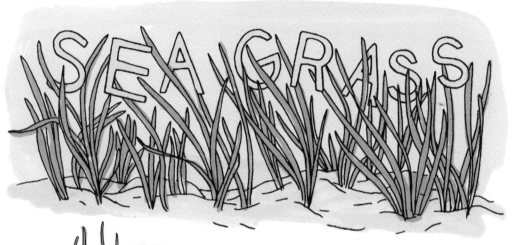

SEAGRASS

HALODULE
PINIFOLIA

HALOPHILA
MINOR

CYMODOCEA
ROTUNDATA

THALASSODENDRON
CILIATUM

Unlike algae seaweeds, seagrasses are true flowering plants that live and pollinate beneath the surface of the ocean.

There are about 60 species of marine grasses. Since they require sunlight to grow, seagrasses take root in sand or mud in shallow, protected areas near shore.

Large seagrass meadows are rich environments that host fish, mollusks, worms, and algae at all stages of development. Seagrasses are an important source of food for manatees, sea turtles, seabirds, crabs, and urchins.

Seagrass meadows help nearby coral reefs by catching particulates and slowing turbulent waters. Sediments settle out in seagrass beds and the clarified water benefits photosynthesis in both grasses and corals.

NUDIBRANCH

The 3,000 species of nudibranchs (pronounced new-dih-branks) exhibit a dizzying array of fluorescent colors and fantastical shapes. They live on the seafloor from Antarctica to the tropics, with the greatest numbers in the shallow tropical waters of coral reefs. These sea slugs are relatives of snails and possess a scraping mouthpart, called a radula, that is studded with rasping teeth for scraping off bits of food. Nudibranchs feed on sponges, jellyfish, corals, anemones, and even other nudibranchs. They find their prey using smell- and taste-sensitive, retractable tentacles called rhinospores on top of their heads.

Nudibranchs do not have shells and so must protect themselves in other ways. The species that feed on stinging jellyfish acquire the jellyfish's nematocysts, or stinging cells, and accumulate them in their surface horns, or cerata. Similarly, some species just eat poisonous algae or sponges, acquiring the toxins and storing them in specialized glands for their own protection.

Individuals are sexually hermaphroditic, meaning they have the sexual organs of both sexes, so any two mature nudibranchs of the same species can mate with each other.

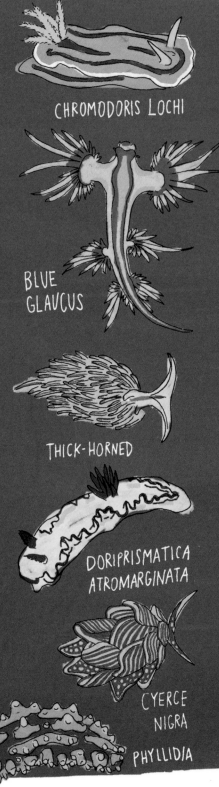

CHROMODORIS LOCHI

BLUE GLAUCUS

THICK-HORNED

DORIPRISMATICA ATROMARGINATA

CYERCE NIGRA

PHYLLIDIA

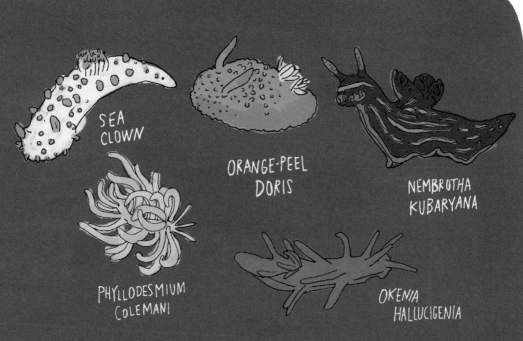

SEA
CLOWN

ORANGE-PEEL
DORIS

NEMBROTHA
KUBARYANA

PHYLLODESMIUM
COLEMANI

OKENIA
HALLUCIGENIA

Some species of nudibranchs deposit their eggs in long ribbons attached to coral or rock as counterclockwise spirals. Certain species' egg masses are well camouflaged, but many are showy and colorful.

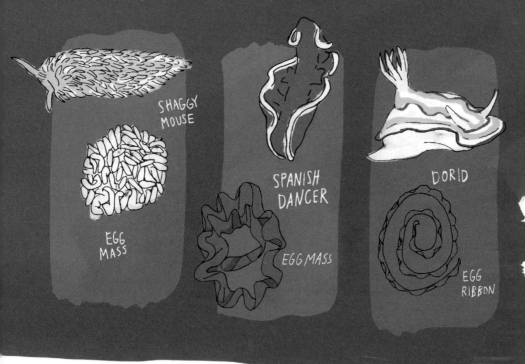

SHAGGY
MOUSE

EGG
MASS

SPANISH
DANCER

EGG MASS

DORID

EGG
RIBBON

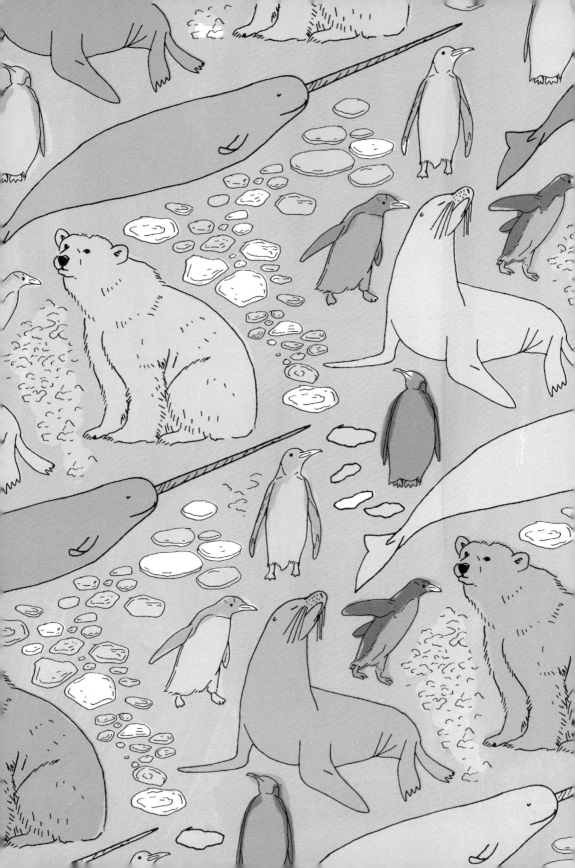

CHAPTER 7

Chill Out

SEA ICE

Sea ice takes different forms depending on its age, surrounding temperatures, wave action, and precipitation. Fifteen percent of the earth's oceans are regularly covered by ice. Much of the Arctic Ocean near the North Pole and the Southern Ocean surrounding Antarctica are covered by sea ice for the majority of each year.

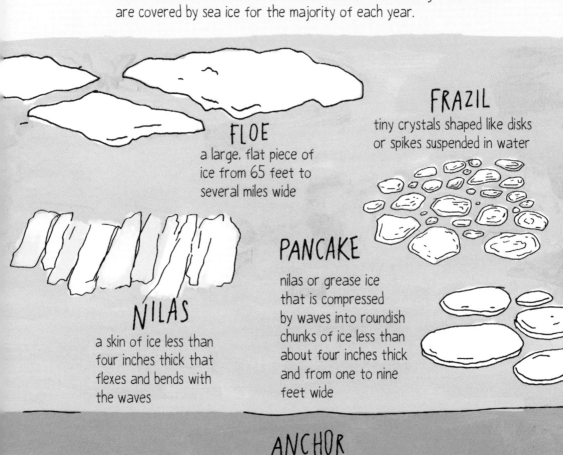

FLOE
a large, flat piece of ice from 65 feet to several miles wide

FRAZIL
tiny crystals shaped like disks or spikes suspended in water

NILAS
a skin of ice less than four inches thick that flexes and bends with the waves

PANCAKE
nilas or grease ice that is compressed by waves into roundish chunks of ice less than about four inches thick and from one to nine feet wide

ANCHOR
clumps of ice that form on the bottom of the ocean

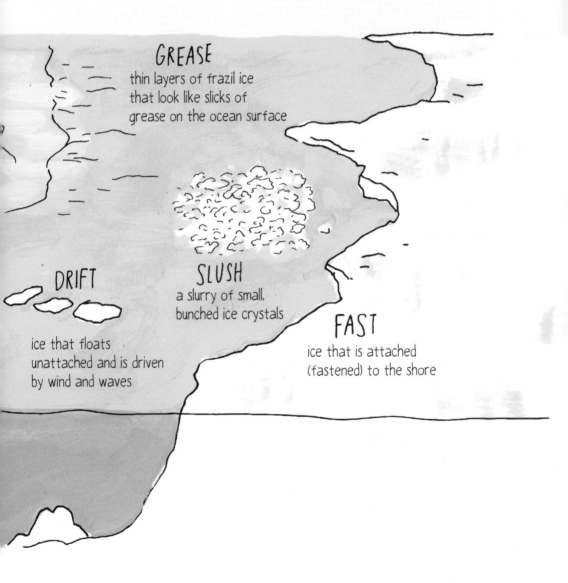

GREASE
thin layers of frazil ice
that look like slicks of
grease on the ocean surface

SLUSH
a slurry of small,
bunched ice crystals

DRIFT
ice that floats
unattached and is driven
by wind and waves

FAST
ice that is attached
(fastened) to the shore

LIFE UNDER THE ICE

The sheets of ice that dominate the polar regions are austere landscapes with extreme conditions. But beneath the thick ice, ocean life flourishes in dramatic colors and forms.

ICEFISH

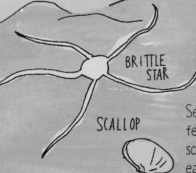

ANTARCTIC OCTOPUS

Though the seawater is a frigid 29°F (-1.7°C), lots of animals feed, breed, and make their homes here.

SKELETON SHRIMP

ANTARCTIC DRAGONFISH

BRITTLE STAR

SEA STAR

SCALLOP

Sea stars, including brittle stars, feast on the abundance of scallops and urchins, and will eat each other if they cross paths.

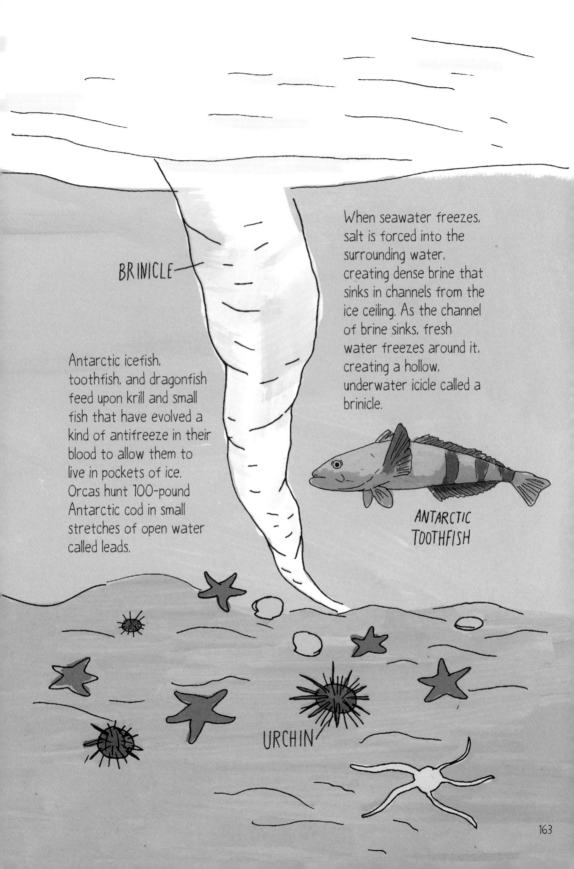

BRINICLE

When seawater freezes, salt is forced into the surrounding water, creating dense brine that sinks in channels from the ice ceiling. As the channel of brine sinks, fresh water freezes around it, creating a hollow, underwater icicle called a brinicle.

Antarctic icefish, toothfish, and dragonfish feed upon krill and small fish that have evolved a kind of antifreeze in their blood to allow them to live in pockets of ice. Orcas hunt 100-pound Antarctic cod in small stretches of open water called leads.

ANTARCTIC
TOOTHFISH

URCHIN

GLACIERS

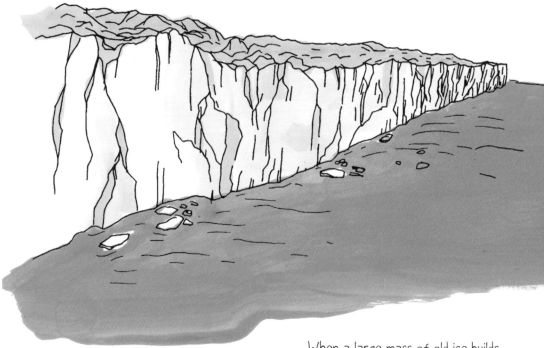

Glaciers form in places where snow falls year after year but never completely melts in the summer. The layers of snow accumulate and compress under their own weight into ice. In places like Antarctica, this ice grows to thousands of feet thick.

When a large mass of old ice builds up in a mountain valley, it slowly flows downhill. These valley glaciers travel anywhere from a few feet to a hundred feet each day.

Glaciers are always made of freshwater ice. When they flow out to the ocean, they are called tidewater glaciers. As the wall of ice reaches the ocean, pieces break off in a process called calving.

Icebergs

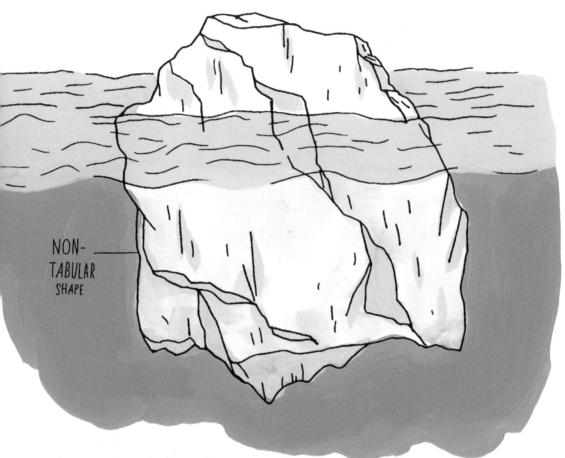

NON-
TABULAR
SHAPE

Icebergs are huge chunks of floating freshwater ice that have broken off of glaciers or ice shelves. Only between 8 and 13 percent of an iceberg's mass is visible above the surface of the water, a fact which contributes to run-ins with ships.

Icebergs are described as tabular if they are substantially longer than they are tall and have a flat top and sides. They are non-tabular if they are shaped like a wedge, dome, pinnacle, or block.

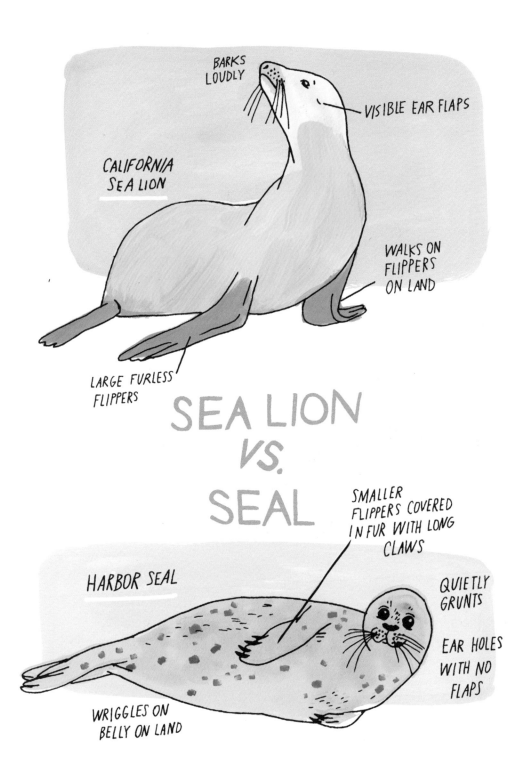

BARKS LOUDLY

VISIBLE EAR FLAPS

CALIFORNIA SEA LION

WALKS ON FLIPPERS ON LAND

LARGE FURLESS FLIPPERS

SEA LION VS. SEAL

SMALLER FLIPPERS COVERED IN FUR WITH LONG CLAWS

HARBOR SEAL

QUIETLY GRUNTS

EAR HOLES WITH NO FLAPS

WRIGGLES ON BELLY ON LAND

Seals, sea lions, and walruses are marine mammals that spend time in and out of the ocean, have four limbs with flippers, and hunt for fish, squid, crustaceans, and mollusks. This group of ocean animals is called pinnipeds.

The closest evolutionary relatives of the pinnipeds are bears and raccoons.

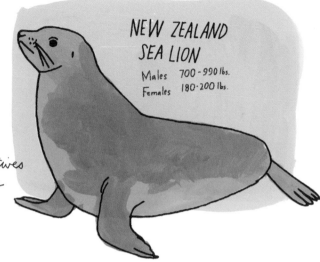

NEW ZEALAND
SEA LION
Males 700 - 990 lbs.
Females 180 - 200 lbs.

SOUTHERN
SEA LION
Males 440 - 770 lbs.
Females 300 - 330 lbs.

Though awkward movers on land, pinnipeds are incredibly quick and nimble acrobats underwater, more flexible and agile even than dolphins. They have very strong senses of smell, vision, and hearing, and they can sense prey using their whiskers, or vibrissae.

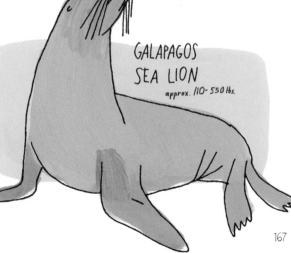

GALAPAGOS
SEA LION
approx. 110 - 550 lbs.

Most pinnipeds prefer the cold waters closer to the earth's poles. They have thick layers of fat and, except for the walrus, very dense fur to keep warm in frigid waters.

167

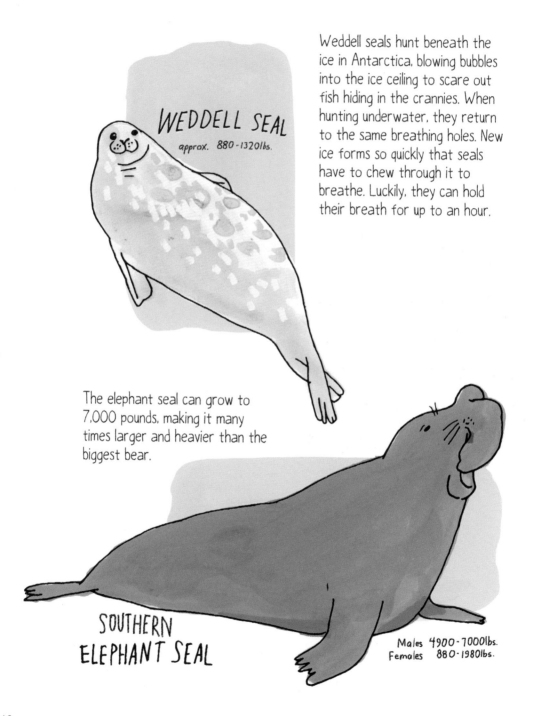

WEDDELL SEAL
approx. 880-1320lbs.

Weddell seals hunt beneath the ice in Antarctica, blowing bubbles into the ice ceiling to scare out fish hiding in the crannies. When hunting underwater, they return to the same breathing holes. New ice forms so quickly that seals have to chew through it to breathe. Luckily, they can hold their breath for up to an hour.

The elephant seal can grow to 7,000 pounds, making it many times larger and heavier than the biggest bear.

SOUTHERN ELEPHANT SEAL

Males 4900-7000lbs.
Females 880-1980lbs.

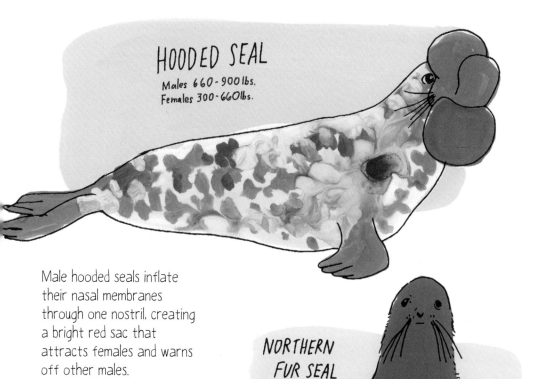

HOODED SEAL

Males 660-900 lbs.
Females 300-660 lbs.

Male hooded seals inflate their nasal membranes through one nostril, creating a bright red sac that attracts females and warns off other males.

To conserve swimming energy, seals leap out of the water between strokes and even surf on waves back to shore. Some have specialized blood, lungs, hearts, and veins that allow them to dive several thousand feet beneath the surface.

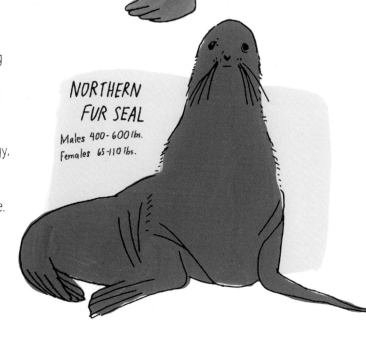

NORTHERN FUR SEAL

Males 400-600 lbs.
Females 65-110 lbs.

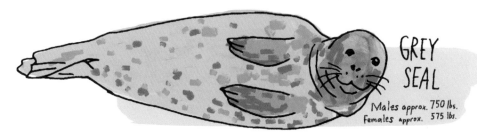

GREY SEAL

Males approx. 750 lbs.
Females approx. 575 lbs.

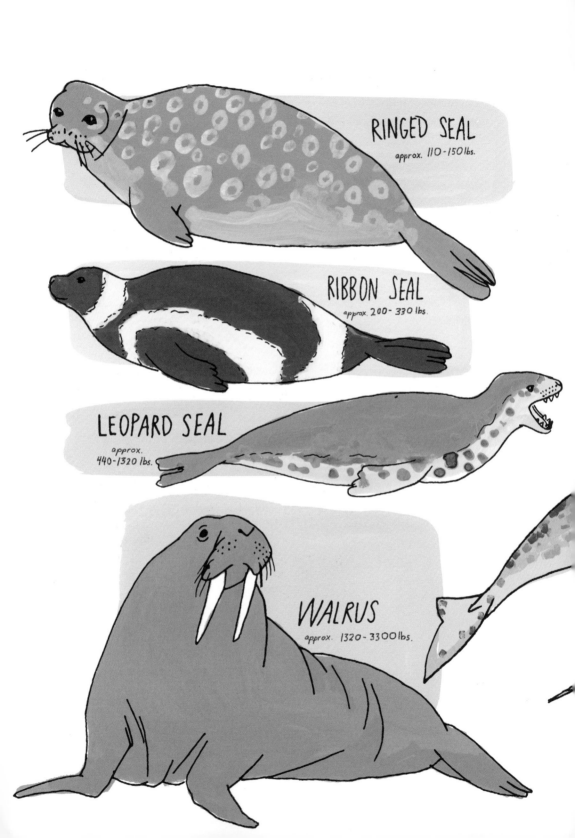

RINGED SEAL
approx. 110-150 lbs.

RIBBON SEAL
approx. 200-330 lbs.

LEOPARD SEAL
approx. 440-1320 lbs.

WALRUS
approx. 1320-3300 lbs.

NARWHALS

These small Arctic whales have a very distinctive feature. The left front tooth of a male narwhal grows about eight feet long in a counterclockwise spiral out of the top lip.

The narwhal's modified tooth is the only straight tusk found in the animal world. Its purpose has been debated for hundreds of years. Could the tusk have to do with social ranking or securing mates, though narwhals have never been witnessed fighting with their tusks? Does it act like a sensitive antenna, providing information about water temperature and salinity so the whales can avoid being trapped beneath rapidly freezing ice? In 2017 a simpler answer appeared — a research drone showed narwhals strike and stun Arctic cod with their tusks before eating them.

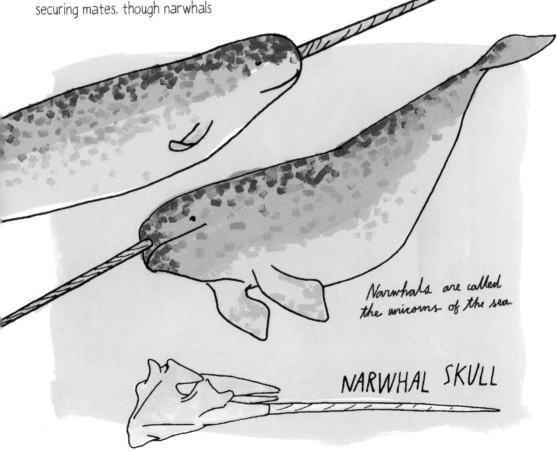

Narwhals are called the unicorns of the sea.

NARWHAL SKULL

PENGUINS

EMPEROR

The vast majority of penguins are found in the cold waters of the far southern hemisphere. They breed and raise young on the shore in colonies numbering from a few hundred to many thousands of individuals.

KING

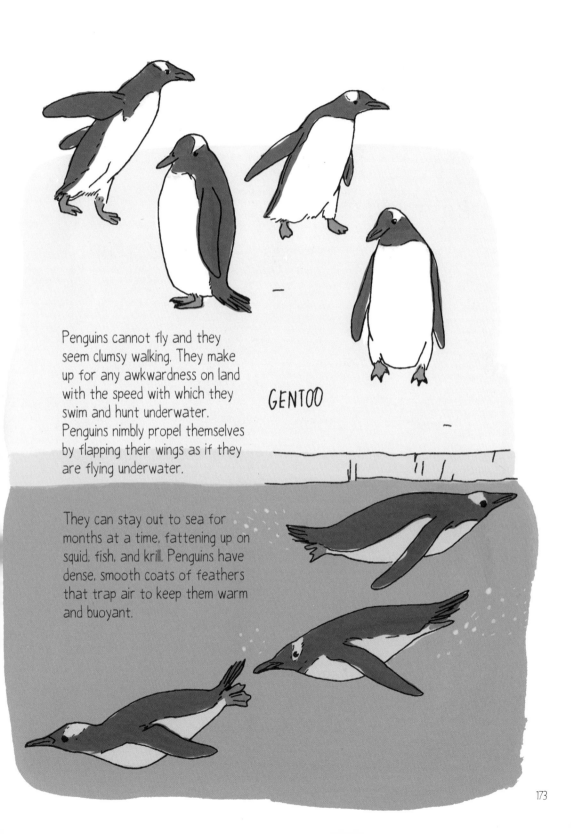

Penguins cannot fly and they seem clumsy walking. They make up for any awkwardness on land with the speed with which they swim and hunt underwater. Penguins nimbly propel themselves by flapping their wings as if they are flying underwater.

GENTOO

They can stay out to sea for months at a time, fattening up on squid, fish, and krill. Penguins have dense, smooth coats of feathers that trap air to keep them warm and buoyant.

MACARONI

All penguins have white bellies and black backs. This coloration, called countershading, acts as camouflage for hunting and confuses predators like sharks, orcas, and leopard seals. The white belly mimics the water's bright surface when viewed from below, while the black back looks like deep water from above.

HUMBOLDT

On smooth ice, penguins save energy by sliding on their bellies, a behavior aptly called tobogganing.

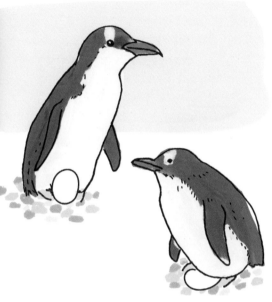

Penguins couple up to raise their young. In most species, both males and females incubate the eggs. They stand upright, nestling the egg between their feet and their warm belly feathers. Once the baby penguins hatch, the parents take turns going to sea to fill their stomachs with fish that they bring back to regurgitate for their hatchlings.

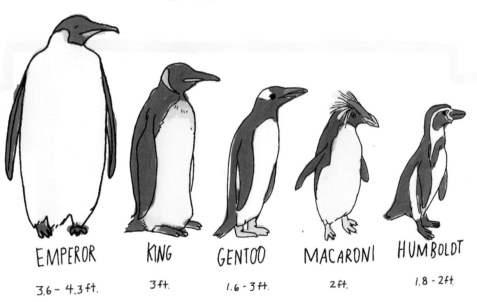

EMPEROR	KING	GENTOO	MACARONI	HUMBOLDT
3.6 - 4.3 ft.	3 ft.	1.6 - 3 ft.	2 ft.	1.8 - 2 ft.

PENGUIN SIZE COMPARISON

POLAR BEARS

Polar bears are considered marine mammals since they spend so much of their lives on Arctic sea ice. Their strong, short claws and large, furry paws are adaptations for walking on snow and slick ice.

Polar bears can travel hundreds of miles through the water. Their large paws are perfect swimming paddles and their thick layers of fat protect against cold water. They are so well insulated that they get overheated and uncomfortable when the weather is warmer than about 50°F (10°C).

Polar bears have black skin that absorbs sunlight and colorless fur that reflects light, appearing white year-round. They are sneaky hunters and use several clever methods to catch ringed, harp, harbor, and bearded seals, their preferred foods.

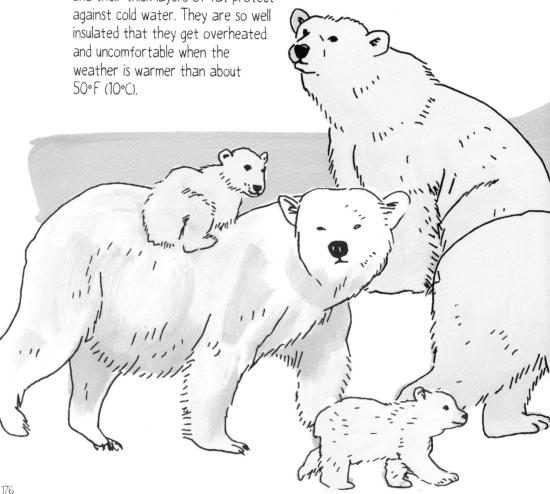

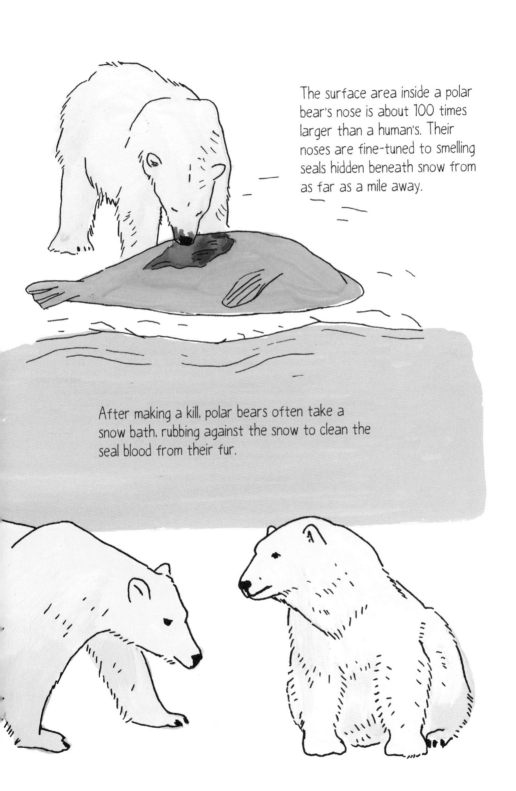

The surface area inside a polar bear's nose is about 100 times larger than a human's. Their noses are fine-tuned to smelling seals hidden beneath snow from as far as a mile away.

After making a kill, polar bears often take a snow bath, rubbing against the snow to clean the seal blood from their fur.

Pregnant female polar bears build dens in the snow and ice. They stay in these dens and may not eat for the first few months while nursing their cubs. The cubs, usually a pair, stay with their mother for about 2½ years.

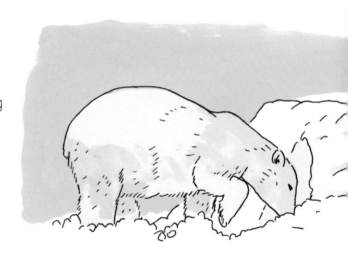

Surrounded by undrinkable saltwater, polar bears are able to process water from the fat of the seals they eat.

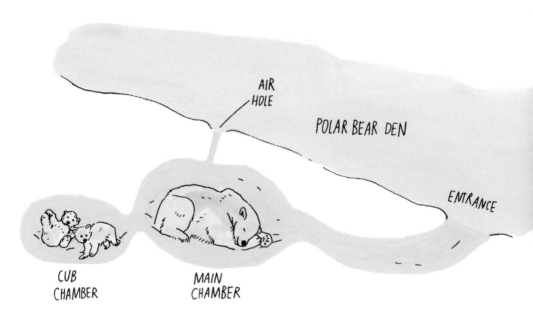

AIR HOLE

POLAR BEAR DEN

ENTRANCE

CUB CHAMBER

MAIN CHAMBER

As human-caused climate change warms the Arctic and melts
sea ice, polar bears are struggling to feed themselves. With the
shrinking ice, polar bears aren't able to hunt enough seals to
meet their high nutritional needs. Adult bears are smaller and less
healthy than in the past. In some populations, mothers can't store
enough body fat to feed and raise their cubs in the den. Survival
rates for cubs are dropping, adult polar bears are less capable
of surviving the ice-free summer, and the health of the whole
population is at risk.

CHAPTER 8

From Sea to Shining Sea

LOW-IMPACT FISHING

Over tens of thousands of years, people have come up with lots of clever ways to catch ocean fish. Spears and harpoons, bows and arrows, handmade nets, clam rakes, and fishing poles with hook and line are some of the more sustainable methods.

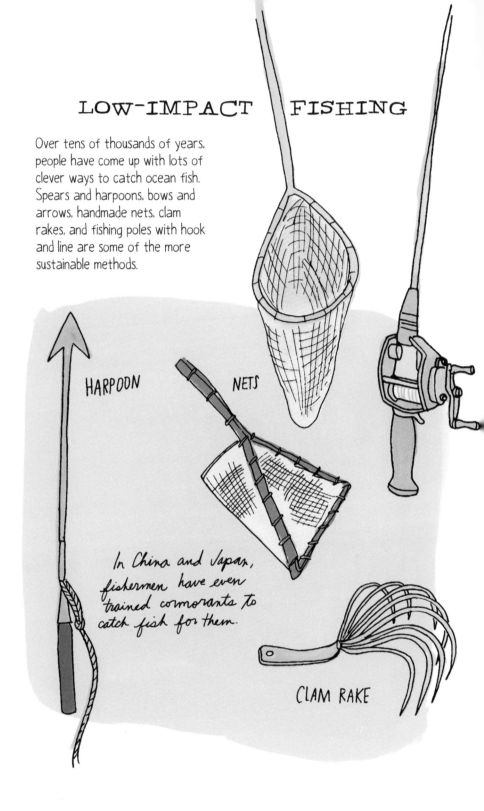

HARPOON

NETS

In China and Japan, fishermen have even trained cormorants to catch fish for them.

CLAM RAKE

Lobster pots and crab pots are baited with dead fish and placed on the seafloor. They have funnel-shaped entrances that the crustaceans can climb into but not escape through. Lobster pots are attached to buoys that float at the surface.

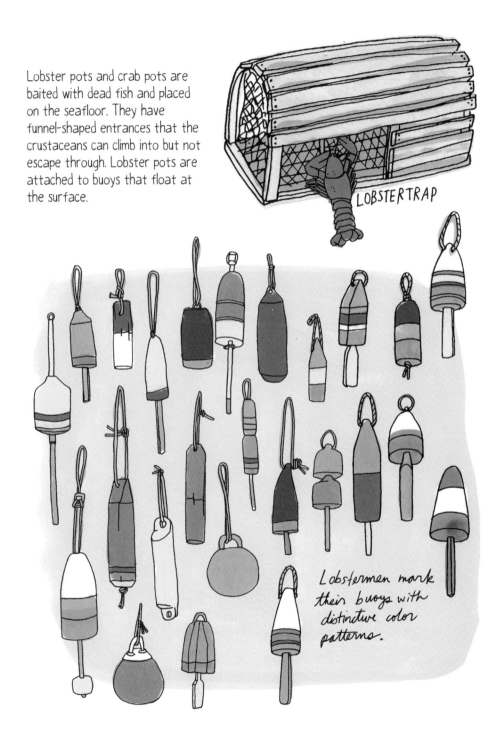

LOBSTERTRAP

Lobstermen mark their buoys with distinctive color patterns.

HIGH-IMPACT FISHING

In the past 200 years, industrialized fishing has negatively affected global fish populations. Large floating factories stay at sea for long periods of time, catching hundreds of tons of fish, cleaning and processing them onboard, and storing the catch in freezers.

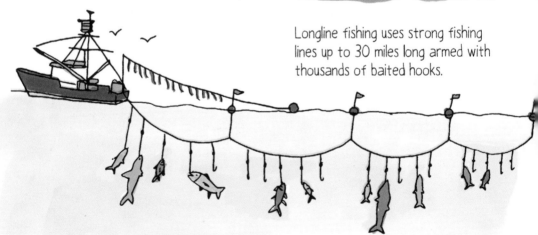

Longline fishing uses strong fishing lines up to 30 miles long armed with thousands of baited hooks.

Purse seine vessels lay out mile-long nets that cinch shut at the bottom. When the net is hauled back onto the ship, it may hold several thousand commercially valuable fish like tuna, sardines, or squid. Every year, these fishing methods kill hundreds of thousands of "unwanted" fish, along with seabirds, turtles, sharks, dolphins, seals, and whales.

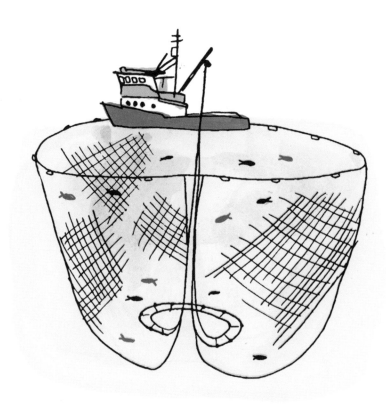

As much as 40 percent of commercial fishing hauls are disposed of as bycatch.

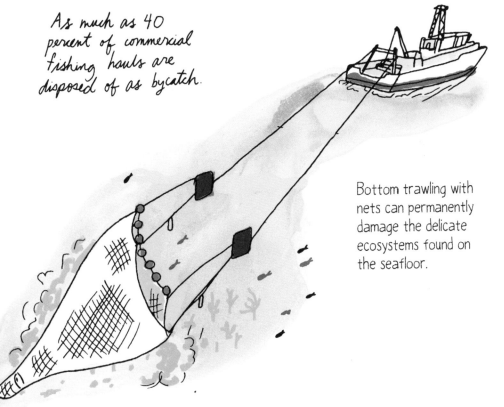

Bottom trawling with nets can permanently damage the delicate ecosystems found on the seafloor.

Lighthouses

Lighthouses aid ships and boats with avoiding rocks and other dangers at sea using a warning light.

Western Brier Island, Nova Scotia

Aviero, Portugal

Race Point, Massachusetts

L A Harbor, California

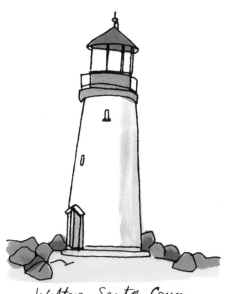

Walton, Santa Cruz,
California

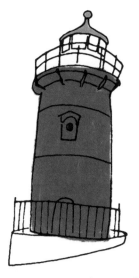

Fort Washington Park,
New York

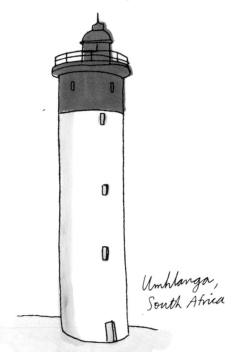

Umhlanga,
South Africa

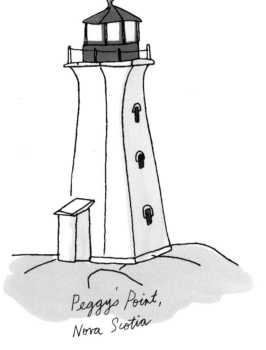

Peggy's Point,
Nova Scotia

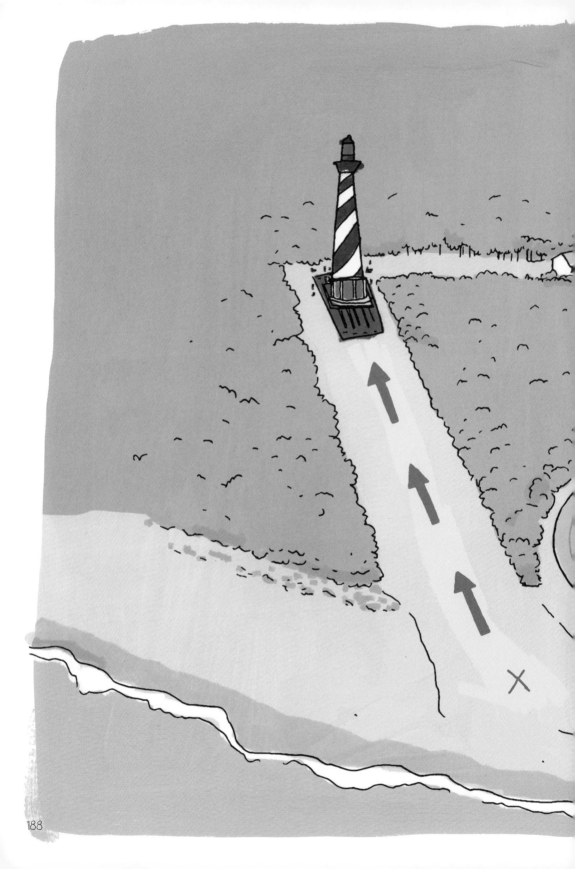

MOVING CAPE HATTERAS LIGHTHOUSE

Since 1803, the shoreline at Cape Hatteras has moved inland by more than a mile.

The Cape Hatteras lighthouse in North Carolina is the tallest lighthouse in the United States, standing 207 feet above the ocean. Built more than a quarter mile from the shore in 1870, the lighthouse's foundation was eventually threatened by ocean waves as the shoreline eroded over 130 years.

In 1999, the National Park Service successfully moved the lighthouse station about 3,000 feet to safer land.

The lighthouse stands 1,600 feet from the ocean now and, depending on the accelerating speed of ocean level rise, it is expected to be threatened by the ocean again in less than 100 years.

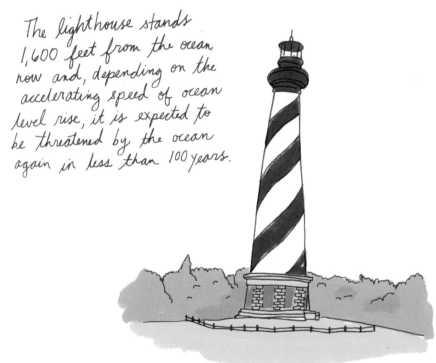

STUDYING THE OCEAN
Oceanographers

Apart from the coastal shallows, very little was known about the ocean until the advent of modern oceanography. In 1872, a British ship, HMS Challenger, began the world's first scientific exploration of the oceans. The Challenger traveled more than 80,000 miles over four years, discovering thousands of new species and conducting hundreds of experiments on ecosystems, depths, temperatures, and composition of the ocean.

Today, oceanographers use state-of-the-art technology aboard dozens of modern ships to study the ocean. As climate change progresses, oceanography is proving critically important; the ocean is the planet's greatest reservoir of heat and carbon dioxide, so learning its capacities may be the key to minimizing negative future effects.

HMS CHALLENGER 1870s

Marine Biologists

Marine biologists study the ocean's living things.

Marta Pola

is a nudibranchs specialist at the Universidad Autónoma de Madrid. "Nudibranchs are interesting to study not only because they are gorgeous and very diverse, they are also very good indicators of the environment." On research trips to Mozambique and the Philippines, her team has discovered more than 60 new species of nudibranchs. "Maybe the cure for cancer is in one of these guys, waiting to be discovered!"

Vicky Vasquez

Vicky Vasquez studies sharks under the Pacific Shark Research Center and is co-host of the podcast Ocean Science Radio. Vicky has worked extensively with great white sharks and her team was the first to successfully tag a Goblin Shark. When she discovered a new species of lanternshark, she asked her four young cousins and kids from the Seven Teepees Youth Program to come up with and promote its name: the Ninja Lanternshark.

Studying the Sea with Alvin

Humans feel pressure building against our ears just a few feet beneath the surface of the water. At 50 feet, that pressure can crush a sealed bottle. At 2,000 feet, it will crush most submarines. But deep sea submersibles are designed to take scientists miles below the surface to collect data on the deep ocean.

Built in 1964, a sub called Alvin has made over 5,000 dives and is still going strong. Alvin can carry two scientists inside its six-foot diameter sphere to depths of nearly three miles. It has two robotic arms for collecting samples and running instruments.

Scientists have discovered hundreds of new species, including some in the ecosystems around deep sea vents, which are the first examples of life not dependent on the sun's energy. Alvin was used to study the effects of the Deepwater Horizon oil spill on the bottom of the Gulf of Mexico and to locate and recover a hydrogen bomb that was lost in the Mediterranean sea in 1966.

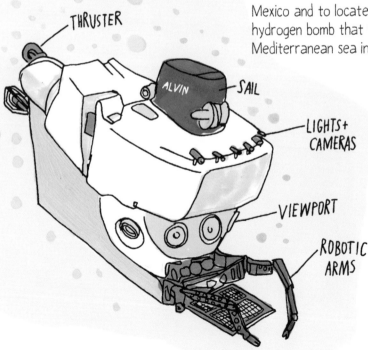

THRUSTER

ALVIN

SAIL

LIGHTS + CAMERAS

VIEWPORT

ROBOTIC ARMS

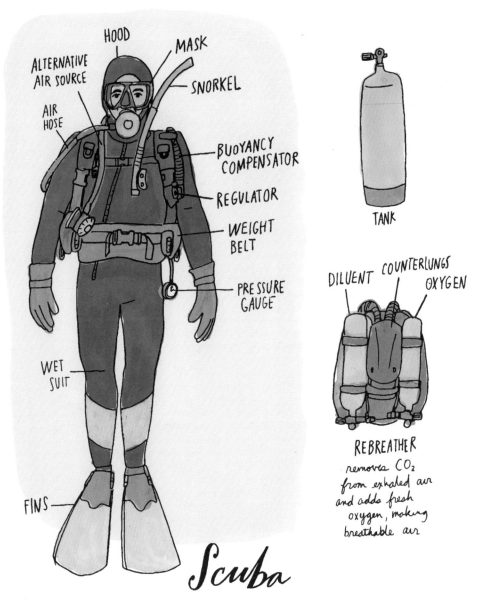

HOOD
MASK
ALTERNATIVE
AIR SOURCE
SNORKEL
AIR
HOSE
BUOYANCY
COMPENSATOR
REGULATOR
WEIGHT
BELT
PRESSURE
GAUGE
WET
SUIT
FINS

TANK

DILUENT COUNTERLUNGS OXYGEN

REBREATHER
removes CO_2
from exhaled air
and adds fresh
oxygen, making
breathable air

Scuba

SCUBA stands for Self-Contained Underwater Breathing Apparatus. With scuba gear, divers can remain underwater for up to an hour on a single air tank. Using a mask, flippers, a weight belt, and a buoyancy vest, a diver can swim beneath the surface like a fish. Since the depth limit for recreational diving is 130 feet, scuba divers tend to explore coral reefs and shipwrecks in relatively shallow water.

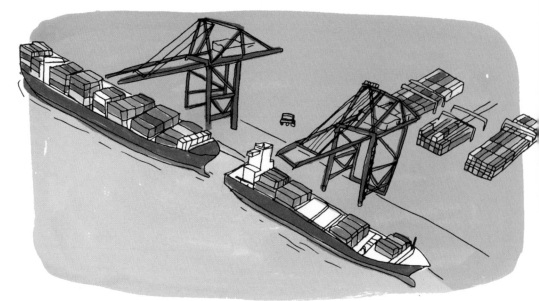

COMMERCE ON THE SEAS

A port is a harbor where ships can load and unload cargo or passengers. Ports tend to be built in protected bays or river mouths where ships are safe from ocean waves and storms.

Deep water ports allow the largest cargo, tanker, and container ships to dock. Deep ports are rare and may require regular dredging of the bottom to maintain open passageways.

Some ports specialize in dealing with bulk cargo, others with containers, passengers, or military ships.

Shanghai, China, the world's busiest port, processes about 40 million containers each year.

Large commercial ports must have specialized cranes, stacking machines, bulk loaders, and forklift trucks to quickly load and unload enormous quantities of cargo and containers. Ports tend to be surrounded by the infrastructure that deals with cargo and raw materials such as warehouses, processing centers, and refineries. Modern ocean ports are well-linked distribution centers connected to highways, railroads, airports, and rivers.

Nautical signal flags are used internationally for ship-to-ship communication.

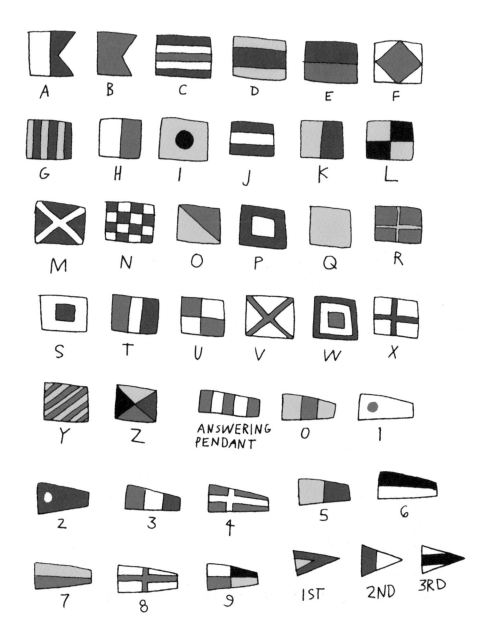

CARGO SHIPS

Ocean shipping is by far the most efficient way to transport large quantities of goods between continents. About 90 percent of global trade relies on the more than 50,000 tanker, cargo, and container ships carrying goods and raw materials across the world's oceans. Almost 100 ships and some 10,000 shipping containers are lost at sea every year, with unknown consequences for the environment.

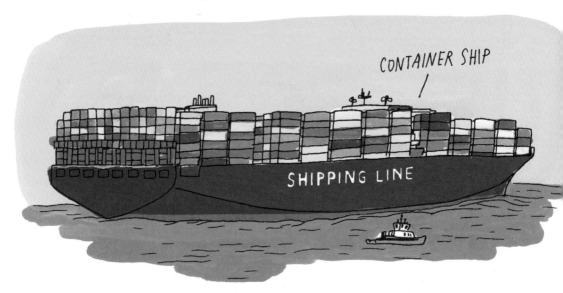

CONTAINER SHIP

SHIPPING LINE

MINIBULKERS	UP TO 15,000 TONS
SUPRAMAX	50,000 TONS
ULTRAMAX	62,000 TONS
PANAMAX	75,000 TONS
POST PANAMAX	98,000 TONS
CAPESIZE	172,000 TONS
VALEMAX (ULTRA LARGE ORE CARRIERS)	400,000 TONS

OIL TANKER

Tankers carry oil, chemicals, gas, or asphalt. Oil tankers range in size from 10,000 tons deadweight to more than 550,000 tons.

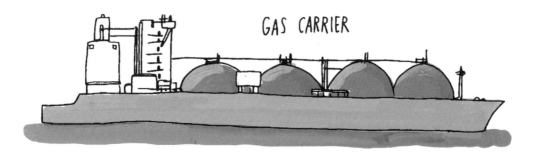

GAS CARRIER

Gas carriers have large, pressurized tanks that can hold hundreds of thousands of cubic yards of liquid natural gas or liquid petroleum gas.

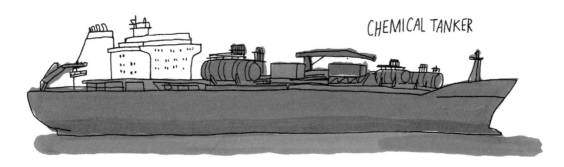

CHEMICAL TANKER

The holds of chemical tankers have special coatings to protect the ship and cargo.

Great Pacific Garbage Patch

Currents in the North Pacific form an enormous spiraling effect, called a gyre, that accumulates and concentrates floating plastic. There are five massive plastic pollution zones in the world's oceans. The largest covers about one million square miles between California and Hawaii.

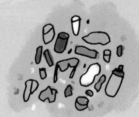

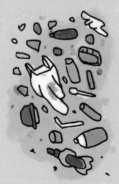

There are nearly two trillion pieces of plastic in the Great Pacific Garbage Patch (GPGP), which weighs about 90,000 tons. That's 285 pieces of plastic for each person on Earth.

This isn't a solid island of floating plastic. Instead, it is an area of increased density of plastic pollution in the upper water column. Much of it is not even visible, since some of the plastic is floating beneath the surface and some is in tiny pieces. UV from the sun and the eroding effects of salt and waves breaks plastic down into smaller and smaller pieces.

MEGAPLASTICS	ANYTHING ABOVE 50CM
MACROPLASTICS	5-50CM
MESOPLASTICS	0.5-5CM
MICROPLASTICS	0.05-0.5CM
NANOPLASTICS	<100NM

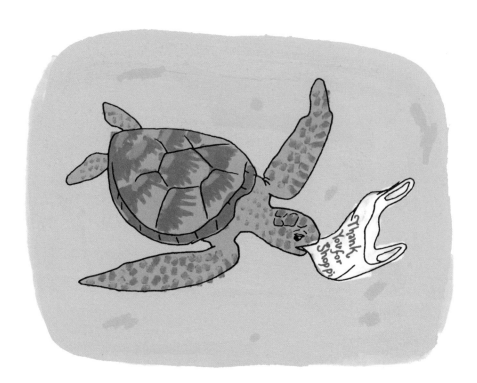

More than 80 percent of the plastics in the GPGP contain at least one type of toxin that accumulates in the bodies of animals.

- Eating plastic instead of food causes malnutrition and threatens the digestive and reproductive health of many animals.

- Sea turtles eat plastic bags, confusing them for jellyfish.

- A dead sperm whale was found to have 13 pounds of plastic in its belly.

- 90 percent of shearwater fledglings and 97 percent of Laysan albatross chicks have plastic in their stomachs.

- One third of fish caught for food in some places have plastic in their stomachs. Plastic toxins enter the human food chain when we consume seafood that has eaten plastic.

- Entanglement in discarded plastic fishing nets is a serious concern for many species.

CLIMATE CHANGE IN NUMBERS

97% OF CLIMATE SCIENTISTS AGREE THAT RECENT CLIMATE-WARMING TRENDS ARE HUMAN-CAUSED.

1.6°F or about 1°C IS HOW MUCH THE EARTH'S AVERAGE TEMPERATURE HAS GONE UP IN THE PAST 100 YEARS, WITH MOST OF THE INCREASE HAPPENING IN THE LAST 35 YEARS.

about **8 INCHES** IS HOW MUCH THE OCEAN HAS RISEN IN THE PAST 100 YEARS.

THE OCEAN IS EXPECTED TO RISE **1-4 FEET** IN THE NEXT 80 YEARS, DUE TO MELTING POLAR ICE AND EXPANSION OF SALTWATER AS IT WARMS.

IN THE NEXT 30 YEARS **0** ICE WILL SURVIVE THE ARCTIC SUMMER.

BECOME A *VISIONARY* AND A *LEADER;* STUDY MARINE SCIENCE OR RENEWABLE ENERGY SCIENCE; *GET INVOLVED* IN LOCAL GOVERNMENT.

Some Good News

For the Oceans

Electric ferries in Norway have reduced carbon emissions by 95% after two years of operation.

Bans on plastic continue to be adopted, from large countries like Kenya and India to the small island nation of Príncipe, off the coast of West Africa.

The Belize Barrier Reef Reserve System, the world's second largest coral reef, is no longer on the endangered list after actions taken by the government to protect it.

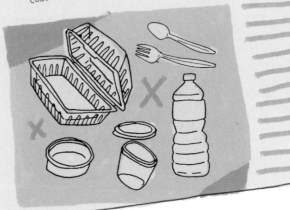

Canada has overhauled its Fisheries Act, requiring rebuilding plans for depleted fish populations and banning the importing and exporting of shark fins.

633 scuba divers set a Guinness World record by collecting more than 1,600 pounds of trash near Deerfield Beach, Florida.

The Indonesian government established three new protected areas within the Coral Triangle, which is home to a rich diversity of reefs and sealife.

Recommended Reading

438 Days: An Extraordinary True Story of Survival at Sea, Jonathan Franklin

Bird Families of the World: A Guide to the Spectacular Diversity of Birds, David W. Winkler, Shawn M. Billerman, and Irby J. Lovette

Blue Mind: The Surprising Science That Shows How Being Near, In, On, or Under Water Can Make You Happier, Healthier, More Connected, and Better at What You Do, Wallace J. Nichols

Encyclopedia of Fishes, John R. Paxton and William N. Eschmeyer

Fishes: A Guide to Their Diversity, Philip A. Hastings, Harold Jack Walker, Jr., and Grantly R. Galland

Kon-Tiki, Thor Heyerdahl

The Log from the Sea of Cortez, John Steinbeck

Marine Biology (Botany, Zoology, Ecology and Evolution), Peter Castro and Michael Huber

Marine Biology for the Non-Biologist, Andrew Caine

Orca: How We Came to Know and Love the Ocean's Greatest Predator, Jason M. Colby

Polar Bears: The Natural History of a Threatened Species, Ian Stirling

Reef Madness: Charles Darwin, Alexander Agassiz, and the Meaning of Coral, David Dobbs

The Sea Around Us, Rachel Carson

Shackleton's Boat Journey, Frank A. Worsley

The Sibley Guide to Birds, David Allen Sibley

The Sixth Extinction: An Unnatural History, Elizabeth Kolbert

Voices in the Ocean: A Journey into the Wild and Haunting World of Dolphins, Susan Casey

Voyage of the Beagle, Charles Darwin

SELECTED RESOURCES AND BIBLIOGRAPHY

Consultant: Dorota Szuta, former field biologist, Coastal Conservation and Research, Santa Cruz, CA; currently water biologist, Los Angeles Department of Water and Power

International Union for Conservation of Nature's Red List of Threatened Species (www.iucnredlist.org/)

National Oceanic and Atmospheric Administration (www.noaa.gov)

Allaby, Michael, ed. *A Dictionary of Earth Sciences*. 4th ed. Oxford University Press, 2013.

---. *A Dictionary of Ecology*. 4th ed. Oxford University Press, 2010.

Dobbs, David. *Reef Madness: Charles Darwin, Alexander Agassiz, and the Meaning of Coral*. Pantheon, 2005.

Ford, John. *Marine Mammals of British Columbia*. Vol. 6. Royal British Columbia Museum, 2014.

Gabriele, C. M., J. M. Straley, and R. J. Coleman. "Fastest Documented Migration of a North Pacific Humpback Whale." *Marine Mammal Science* 12, no. 3 (1996): 457-64.

HüNeke, Heiko, and Thierry Mulder, eds. "Deep-Sea Sediments." *Developments in Sedimentology* 63:1-849.

Mather, J. A., and M. J. Kuba. "The Cephalopod Specialties: Complex Nervous System, Learning and Cognition." *Canadian Journal of Zoology* 91, no. 6 (2013): 431-49.

Rothwell, R.G. "Deep Ocean Pelagic Oozes." *Encyclopedia of Geology*. Edited by Richard Selley, Leonard Morrison Cocks, and Ian Plimer. Vol. 5. Elsevier, 2005.

Ruppert, Edward E., Richard S. Fox, and Robert D. Barnes. *Invertebrate Zoology: A Functional Evolutionary Approach*. 7th ed. Cengage Learning, 2003.

THANK YOU!

Thanks again to all the kids (and adults!) who have written to me and gave me the motivation to do another one of these books, which take so long!

Thanks John Niekrasz for doing all the incredible writing and research and finding such fascinating information to include.

Thanks always to my editor Lisa Hiley and art director Alethea Morrison and to the entire staff of Storey Publishing who are a huge pleasure to work with.

Thanks to Eron Hare for all the painting help. And the good conversations while we worked.

Thanks to my family and friends who give me so much support.

Thanks to everyone who helps to protect our oceans and all their unique creatures.

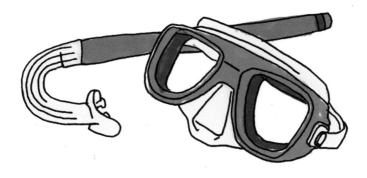

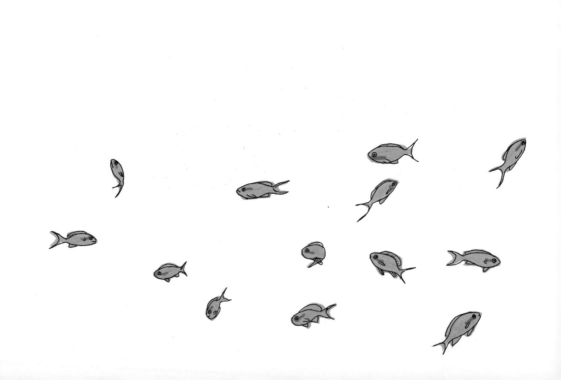